The
Flowers
COLORING
BOOK

SIRIUS

SIRIUS

This edition published in 2023 by Sirius Publishing, a division of
Arcturus Publishing Limited,
26/27 Bickels Yard, 151–153 Bermondsey Street,
London SE1 3HA

ISBN: 978-1-3988-2601-4
CH010999NT
Supplier 13, Date 0623, PI 00003252

Printed in China

Index of plates

6–7 Bouquet of roses
8–9 Auricula or mountain cowslip
10–11 Anemone stellata
12–13 Blanket flower
14–15 Lilium bulbiferum (Tiger lily)
16–17 Dutch iris
18–19 Gentiana acaulis
20–21 Harlequin flower
22–23 Lilas (Lilac)
24–25 Crown imperial
26–27 Primula sinensis
28–29 Bunch-flowered narcissus
30–31 Varieties of Nigella
32–33 Hippeastrum variety
34–35 Dianthus albo-nigricans
36–37 Tulip
38–39 Cheiranthus flavus (Wallflower)
40–41 Crown imperial (Yellow variety)
42–43 Tagetes (Marigold)
44–45 Japanese camellia
46–47 Centaurea cyanus (Cornflower)
48–49 Snapdragon
50–51 Gazania splendens
52–53 Blue Egyptian water lily or blue lotus
54–55 Bouquet of rose, anemone and clematis
56–57 Angel's trumpet
58–59 Azalia indica gigantiflora
60–61 Nettle-leaved bellflower
62–63 Petunia inimitabilis
64–65 Dwarf morning glory
66–67 Rosa pomponia
68–69 Blue plantain lily
70–71 Cactus grandiflora
72–73 Poppy anemone
74–75 Primavera grandiflora
76–77 Dahlia
78–79 Lechnenaultia biloba
80–81 Oleander
82–83 Bouquet of pansies

84–85 Lychnis Coronata
86–87 Phlox reptans
88–89 Snake vine
90–91 Geranium variety
92–93 Tulip tree
94–95 Plumbago cerulea
96–97 Sweet pea
98–99 Fuchsia solferino
100–1 Dalmatian iris
102–3 Geum coccineum
104–5 Sulpher rose
106–7 Gloxinia variety
108–9 Gladiolus cuspidatus
110–1 Lavetera phoenicea
112–3 Poppy
114–5 Platylobium
116–7 Common hyacinth
118–9 Ixia viridiflora
120–1 Knyssa lily
122–3 Punica granatum var. legrelliae
124–5 Chinese peony
126–7 Lonicera (honeysuckle)
128–9 Amaryllis variety
130–1 Digitalis purpurea
132–3 Blue false indigo
134–5 Rosa gallica
136–7 Winged-stem passion flower
138–9 Hortensia
140–1 Hanging bells
142–3 Coreopsis elegans
144–5 Fringed iris
146–7 Crocus sativus
148–9 China aster
150–1 Aquilegia spectabilis
152–3 Tropaeolum majus
154–5 Rosa indica
156–7 Lady's slipper orchid
158–9 Hellebore and carnations

Introduction

Flowers have always made fascinating subjects for artists and they are a wonderful challenge to replicate. This book contains a selection of 77 beautiful flower paintings by renowned botanical artists for you to color. The simple line drawings alongside are reproduced directly from the artists' sketches and are waiting for you to add color and detail. One of the best ways to learn is by copying the masters.

Watercolor paint or colored pencils are the best mediums to use for these illustrations—you may find the latter easier to start with. Be sure to blend your colors and follow the natural direction of the subject's textures, working along the lines of the leaves and petals to faithfully re-create these natural wonders.

All of the artwork in this book has been drawn from either the *L'illustration horticole*, a 19th-century Belgian journal founded by Jean Jules Linden in 1854 and illustrated by some of the finest botanical artists and lithographers of the day, including A. Goossens, P. De Pannemaeker, and J. Goffart; or from *Choix des plus belles Fleurs* (Choice of the Most Beautiful Flowers), published in 1827 and illustrated by Pierre-Joseph Redouté. A one-time court artist to Marie Antoinette, Redouté illustrated more than 1800 plant species and remains one of the most famous artists in the genre of botanical painting, even in the 21st century.

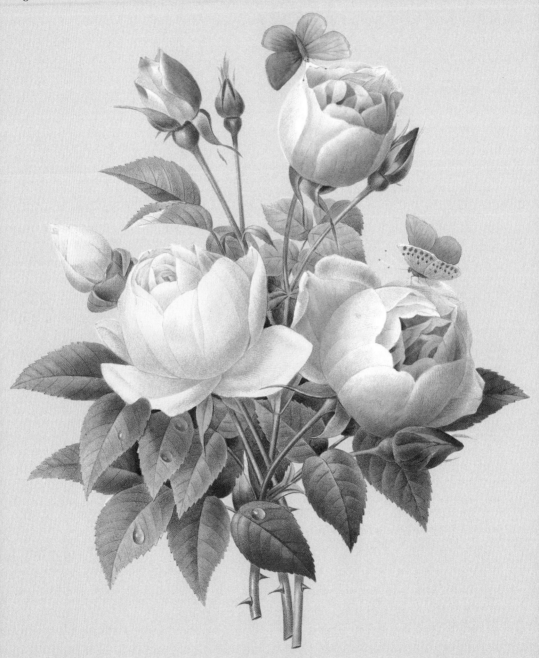

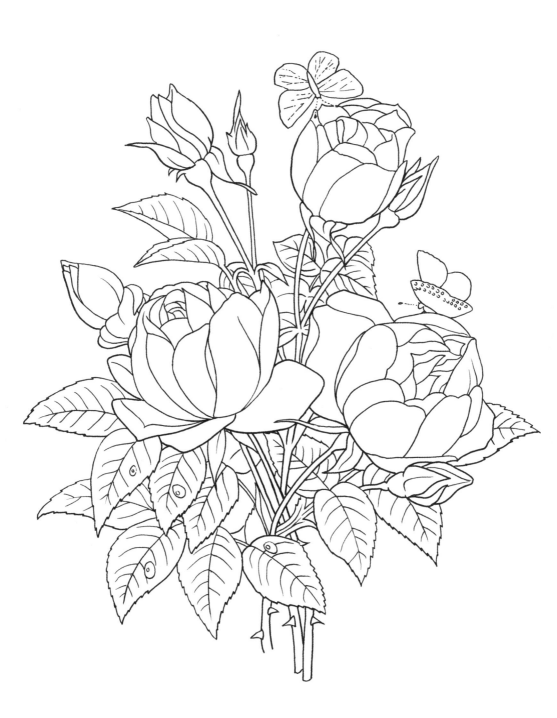

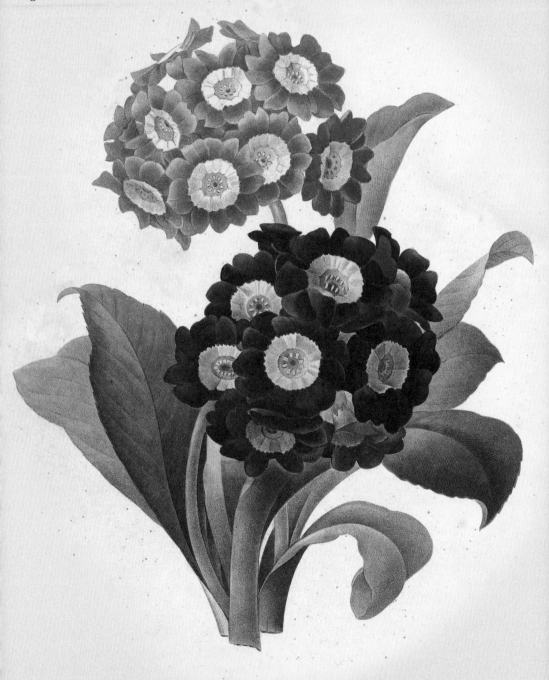

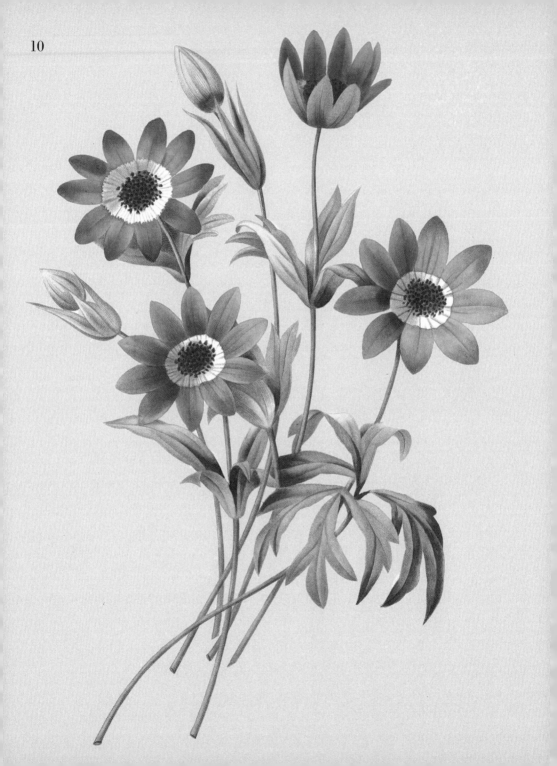

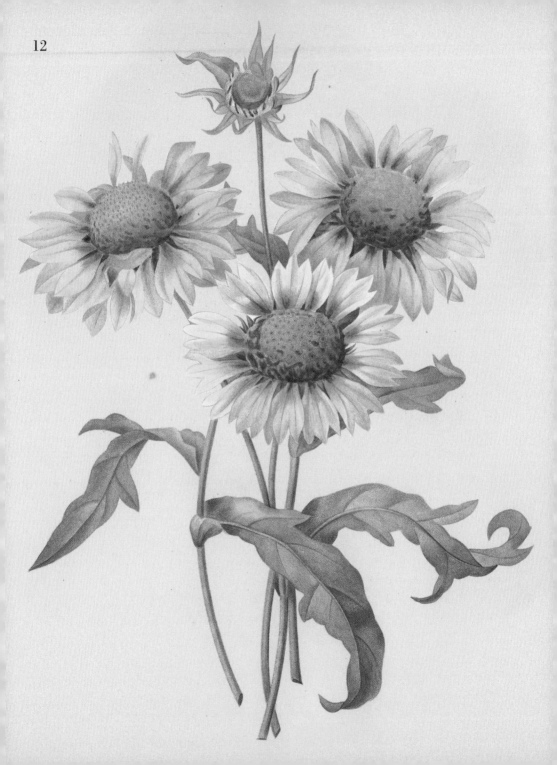

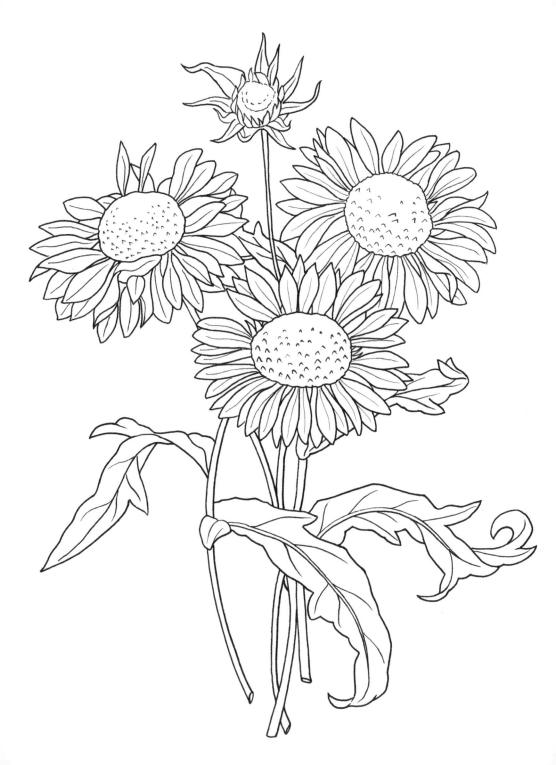

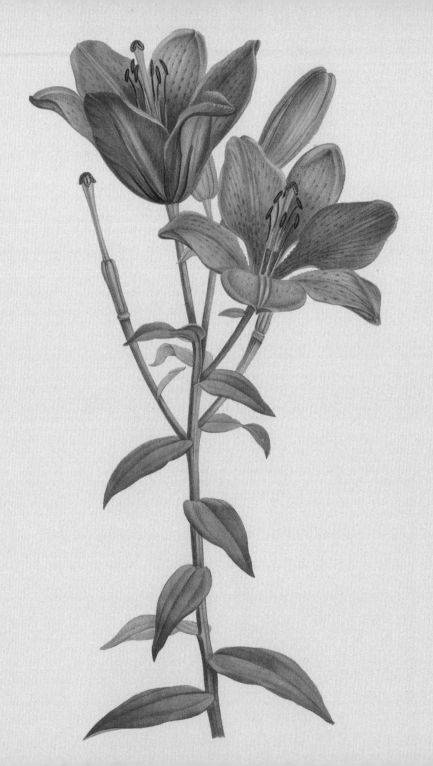

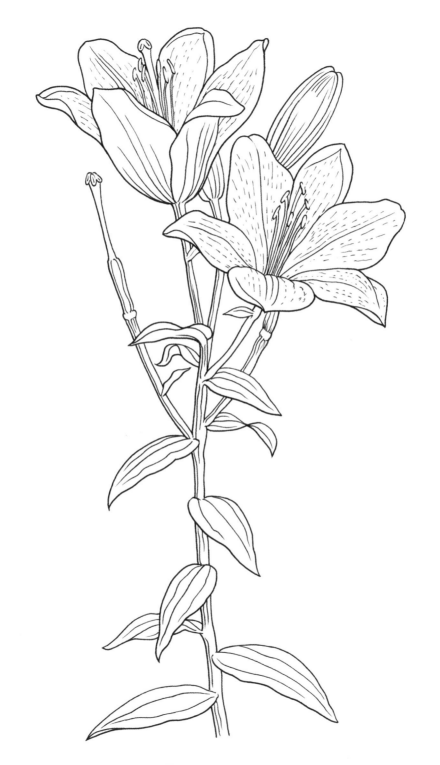

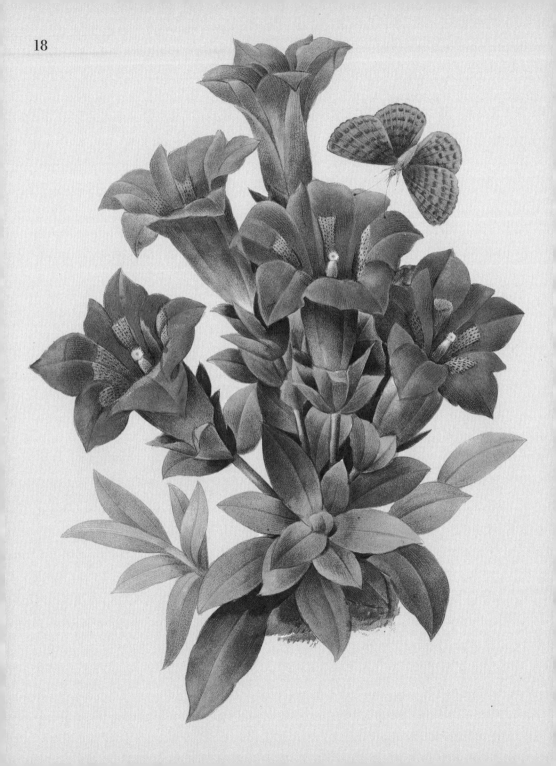

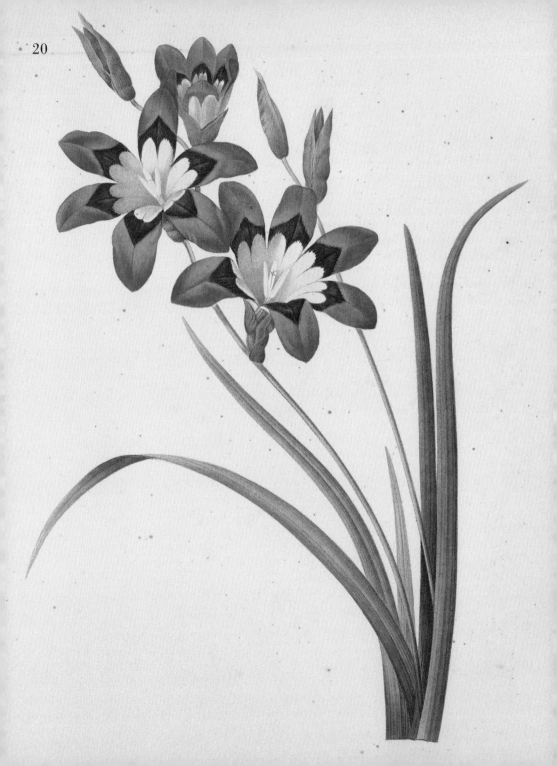

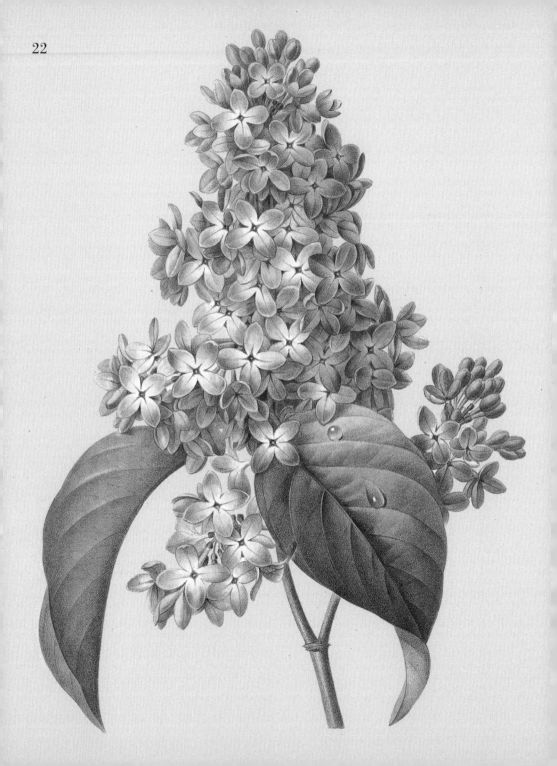

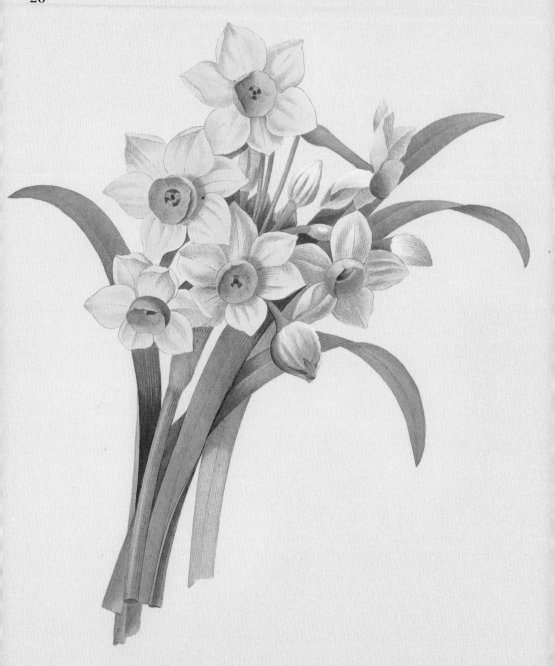

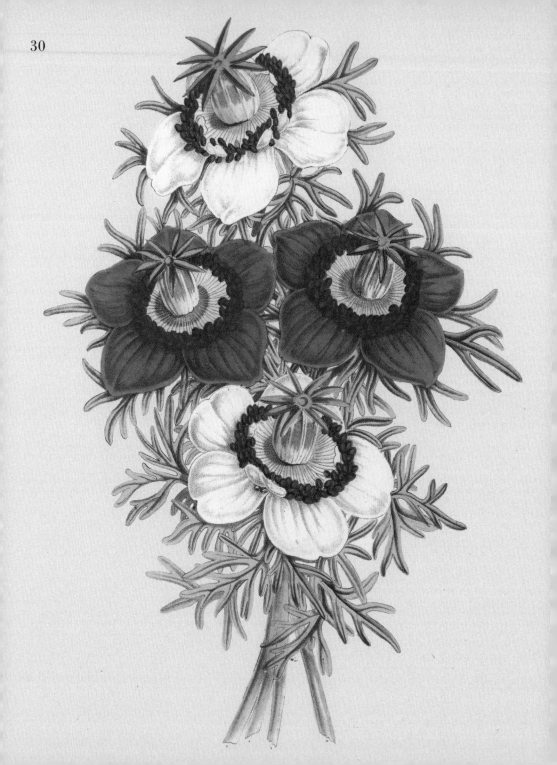

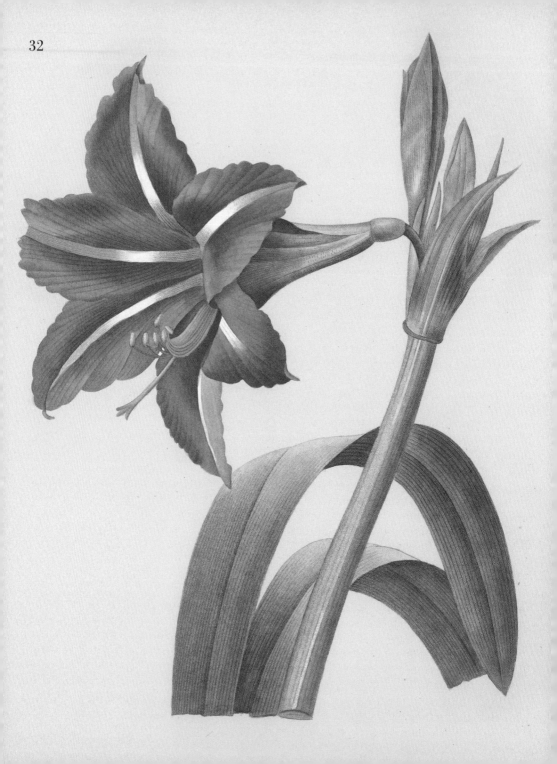

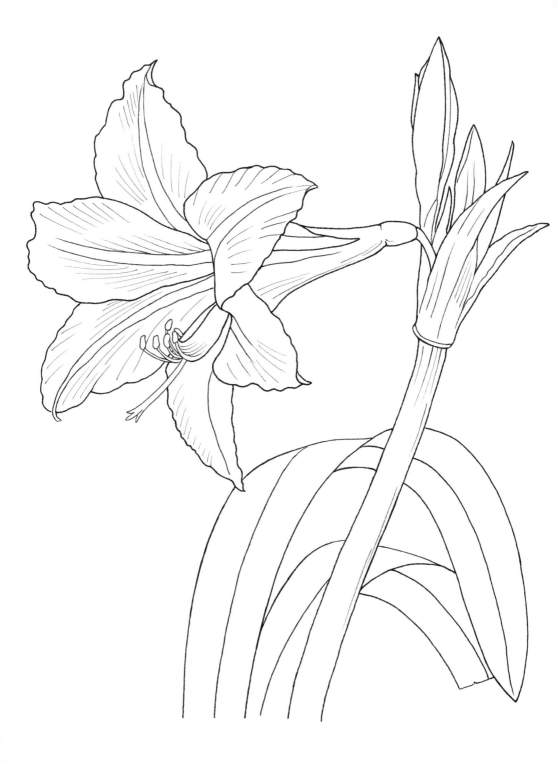

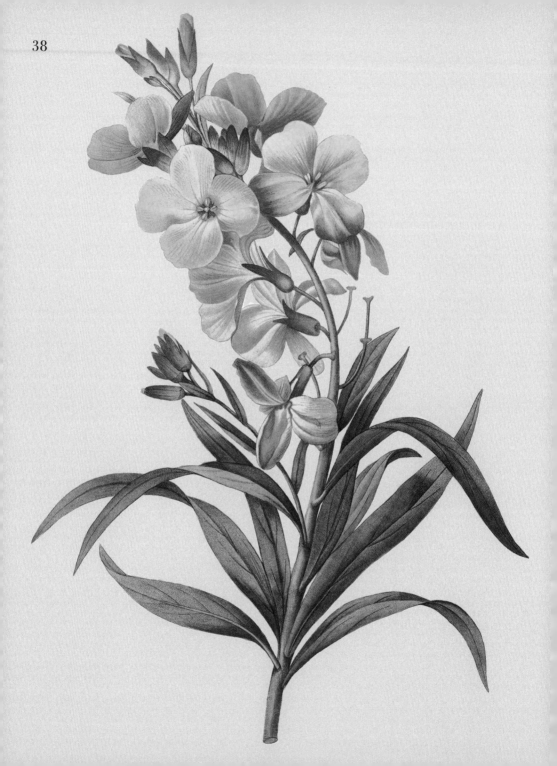

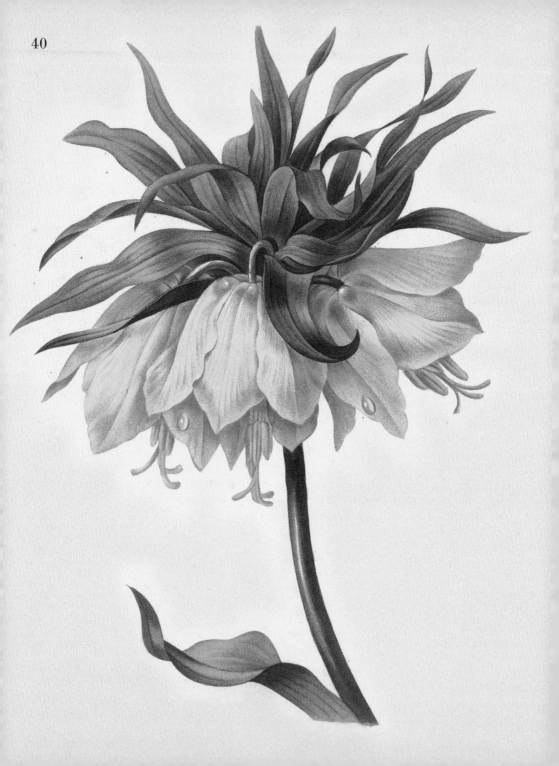

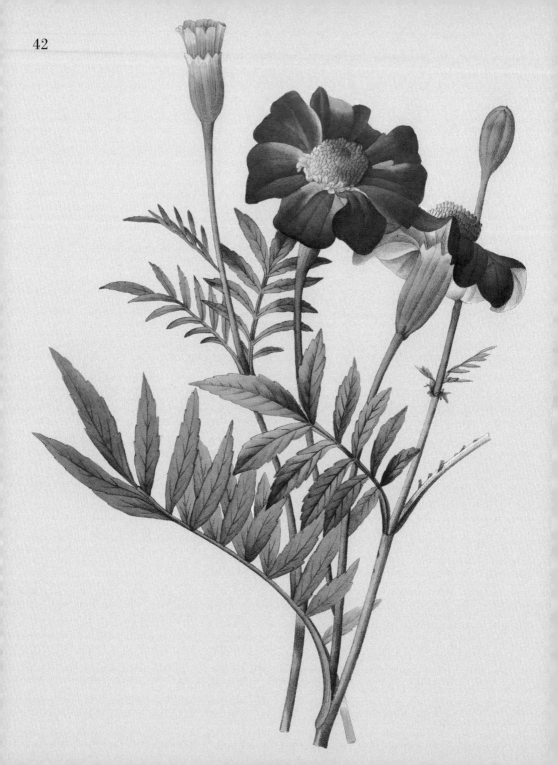

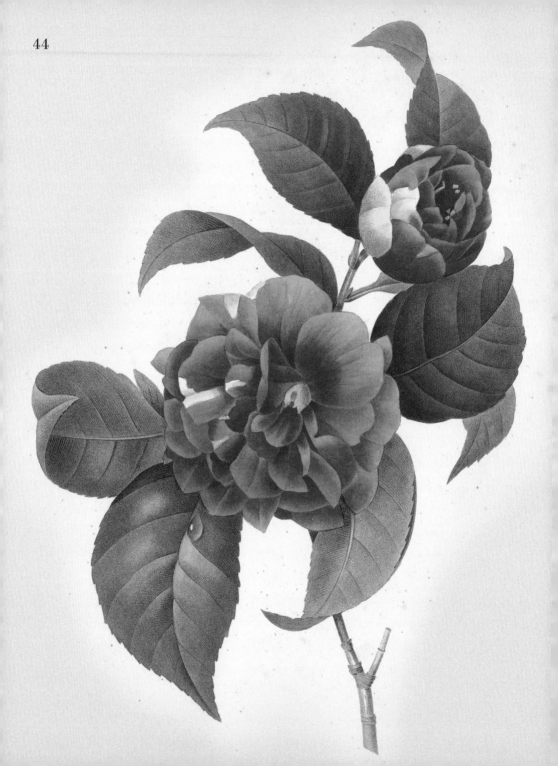

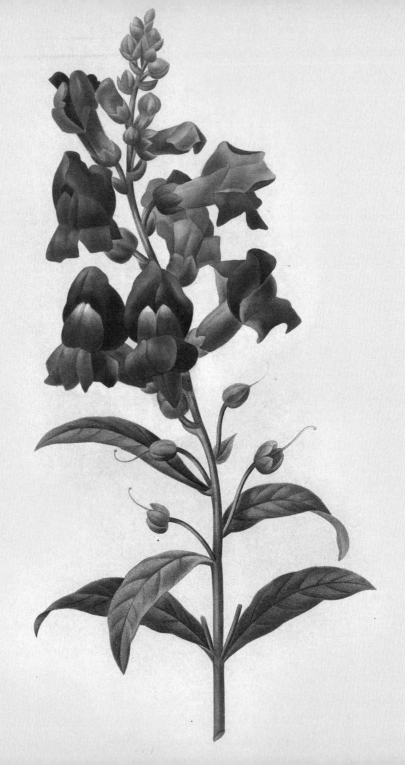

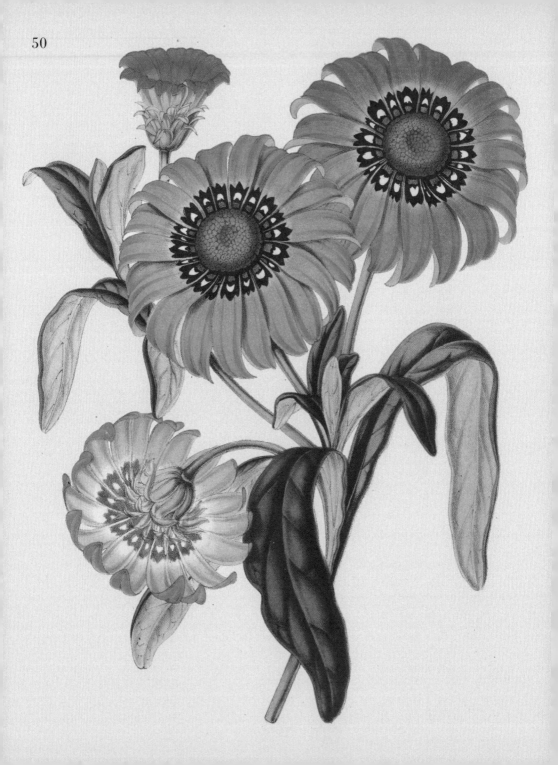

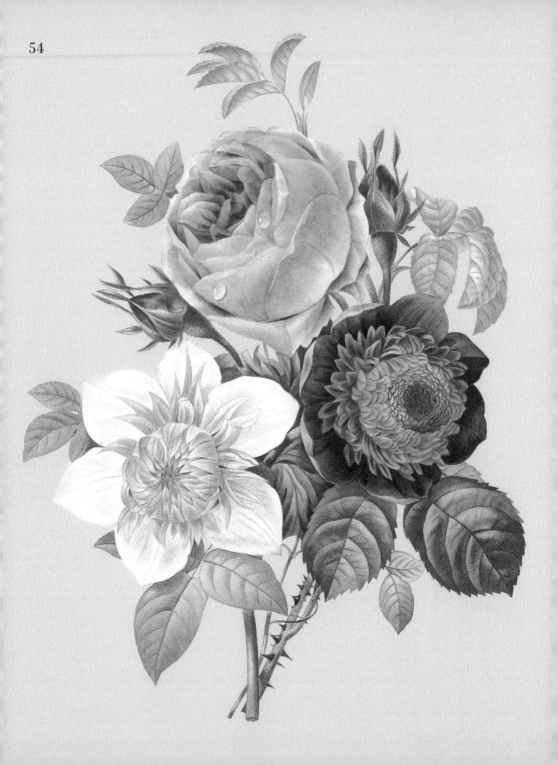

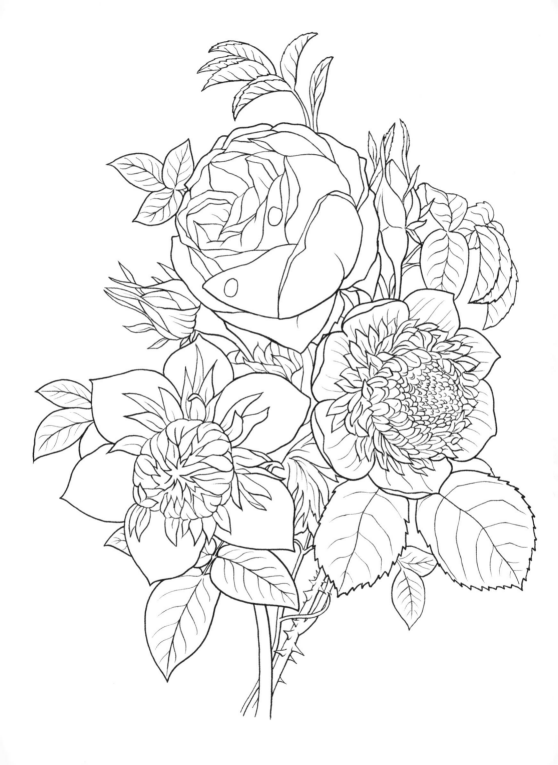

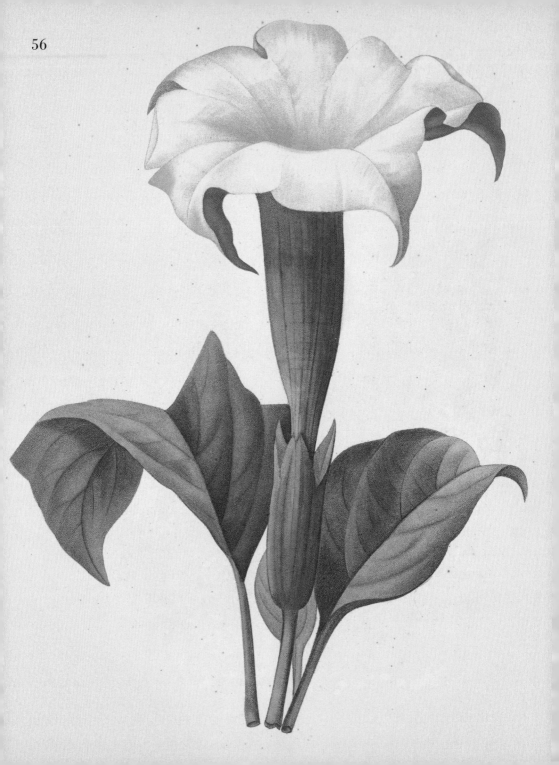

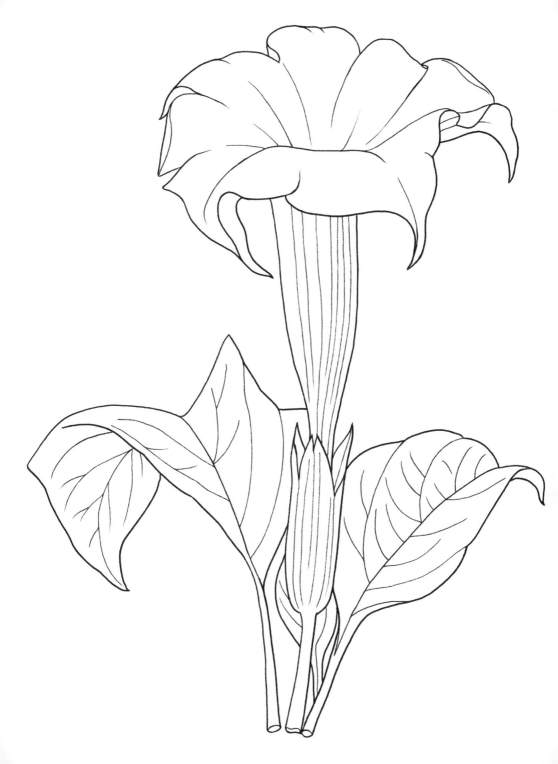

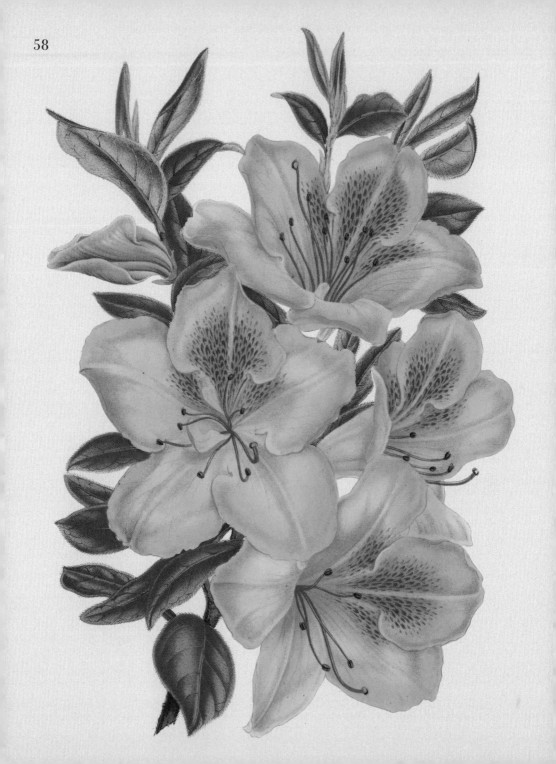

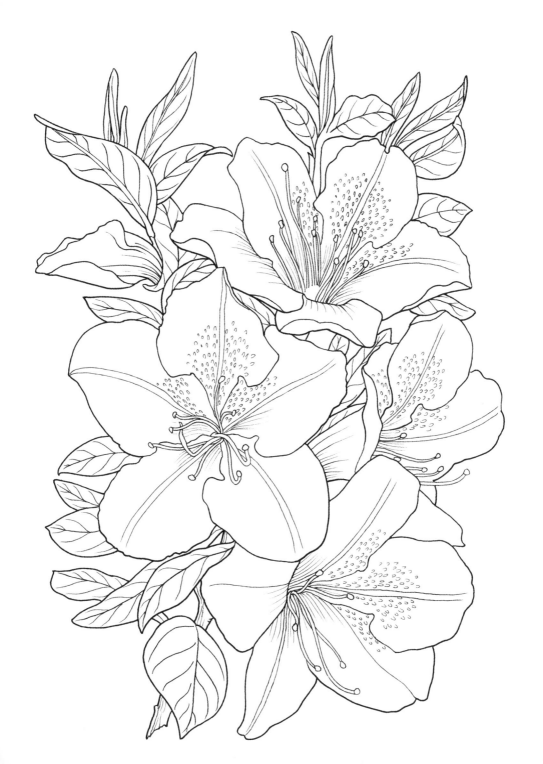

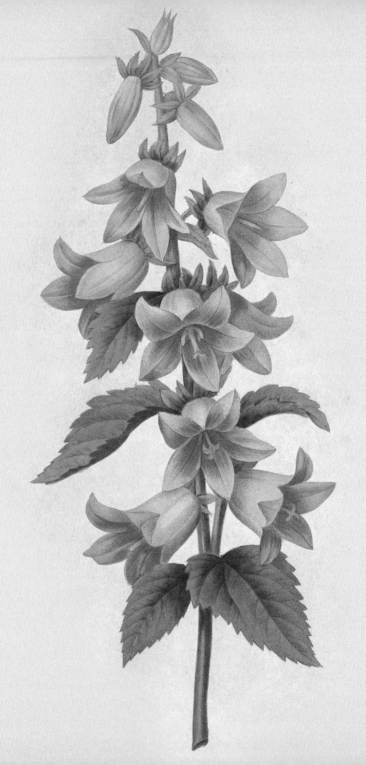

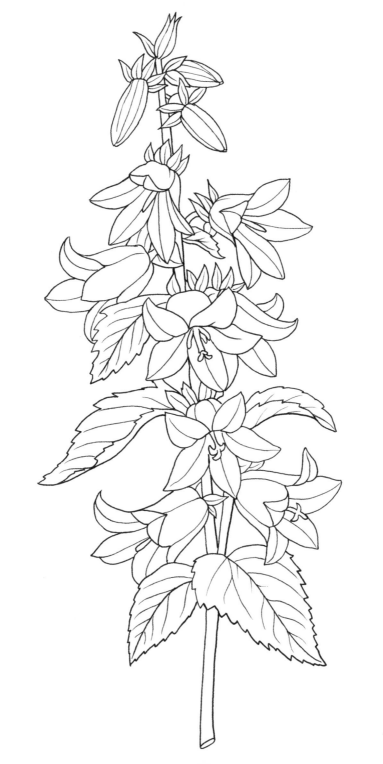

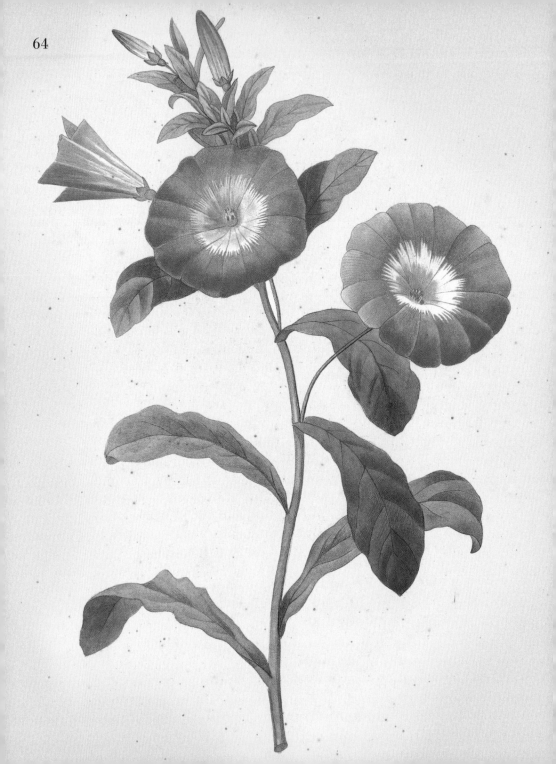

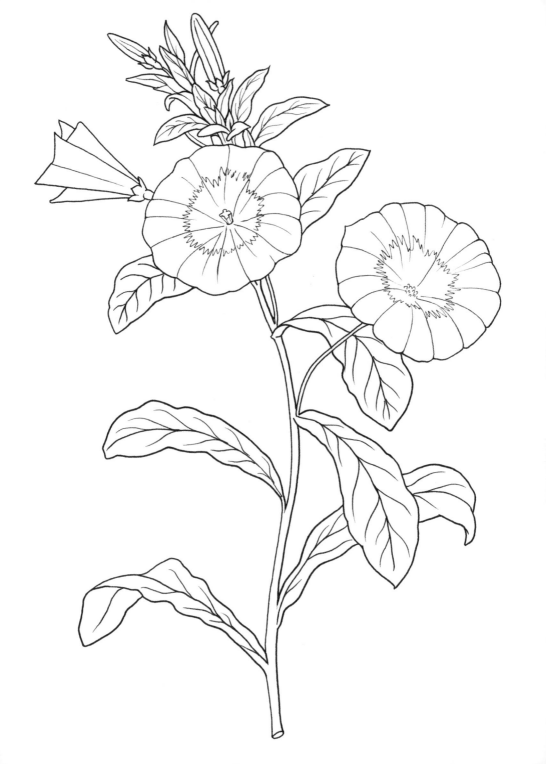

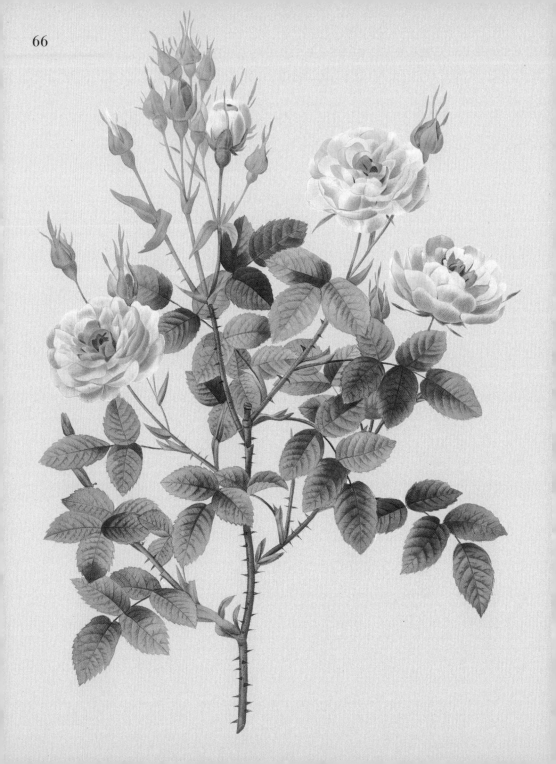

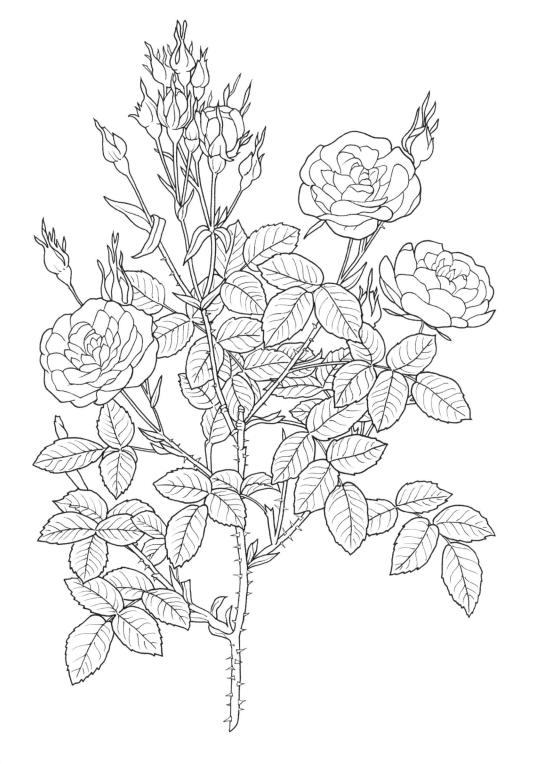

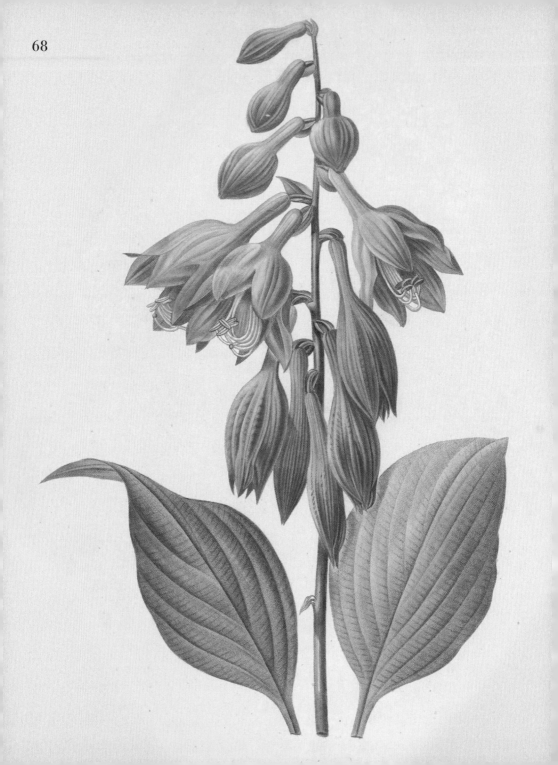

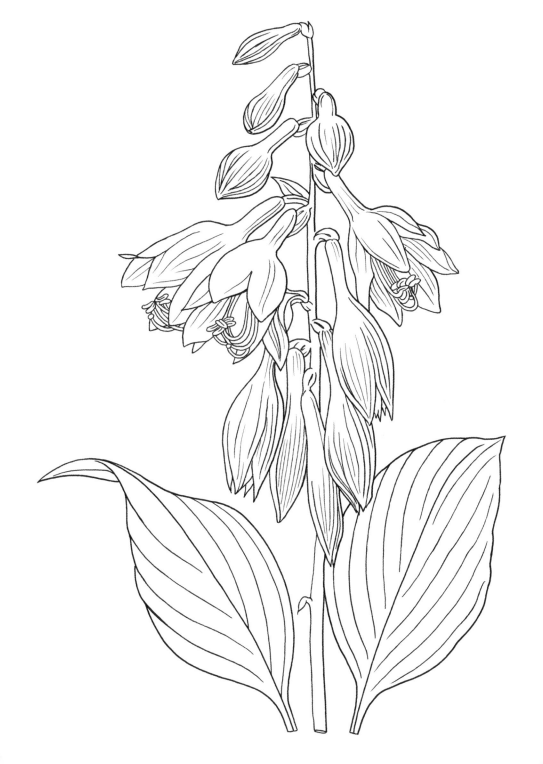

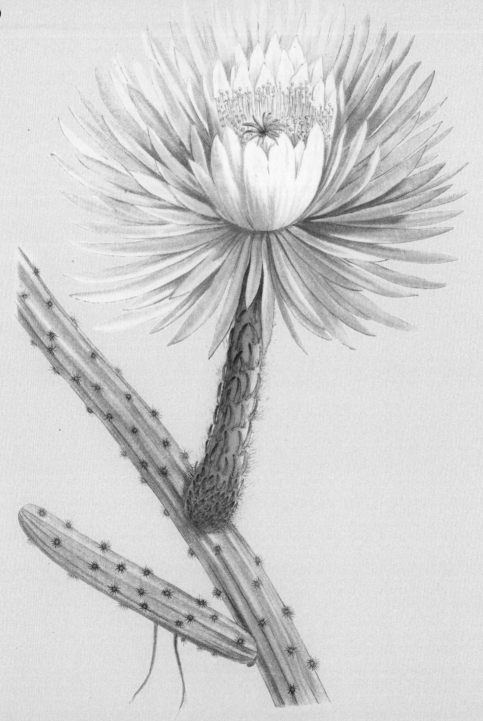

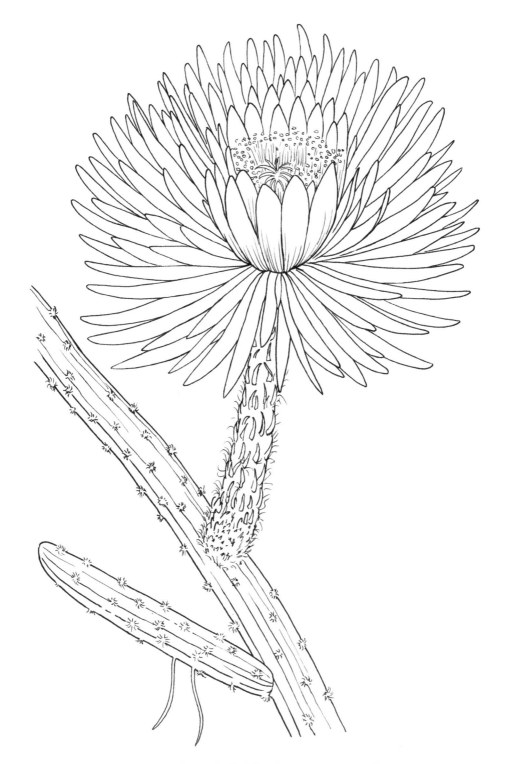

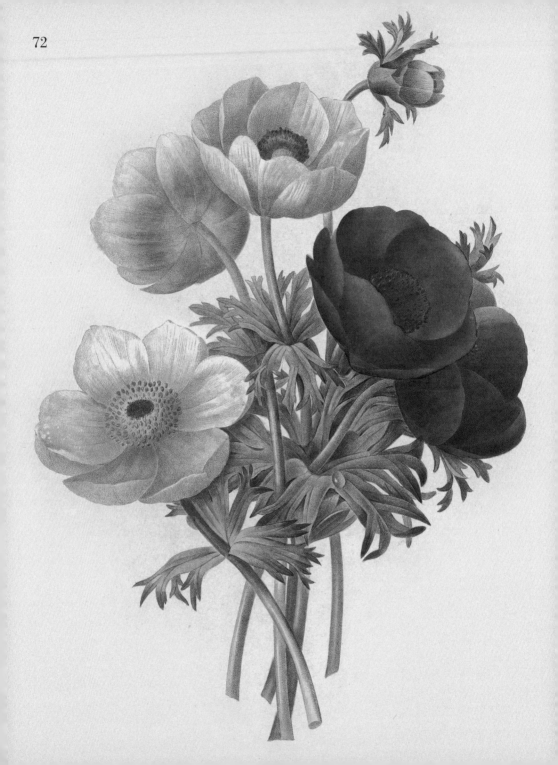

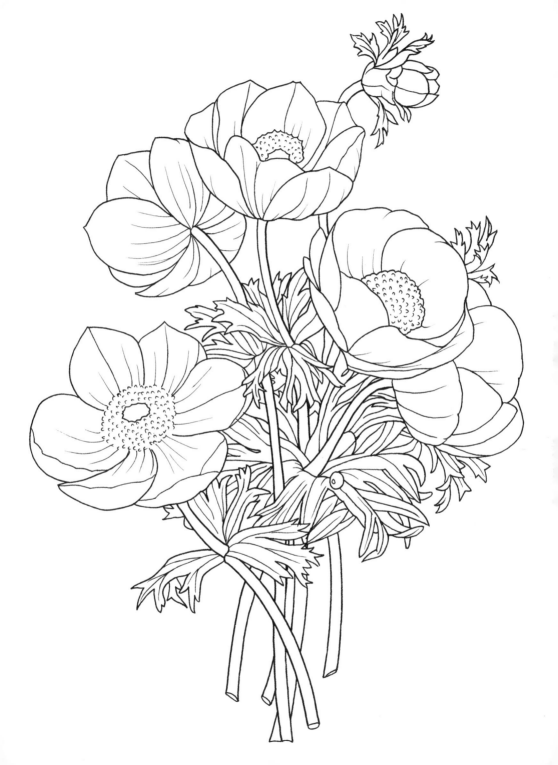

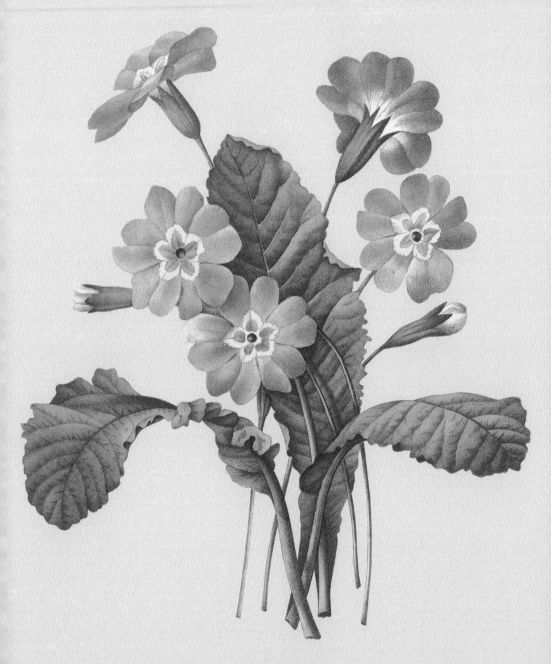

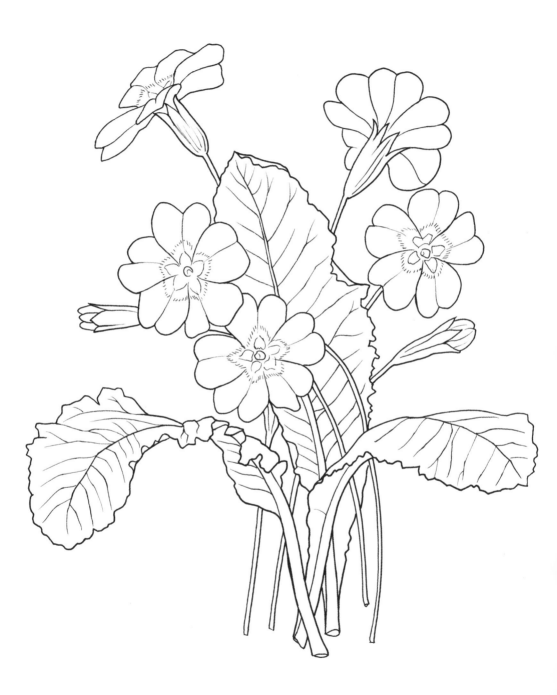

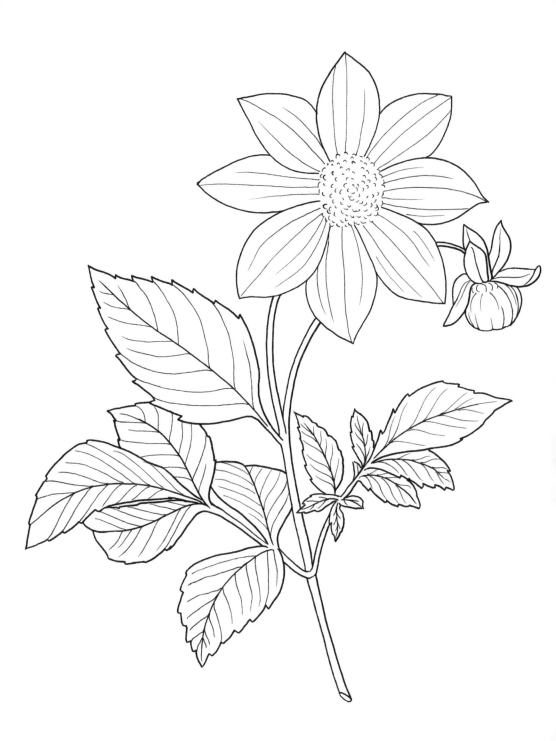

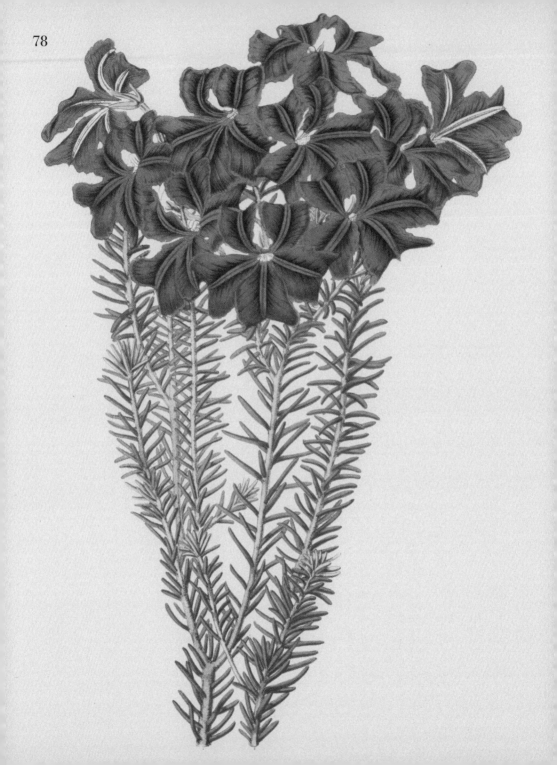

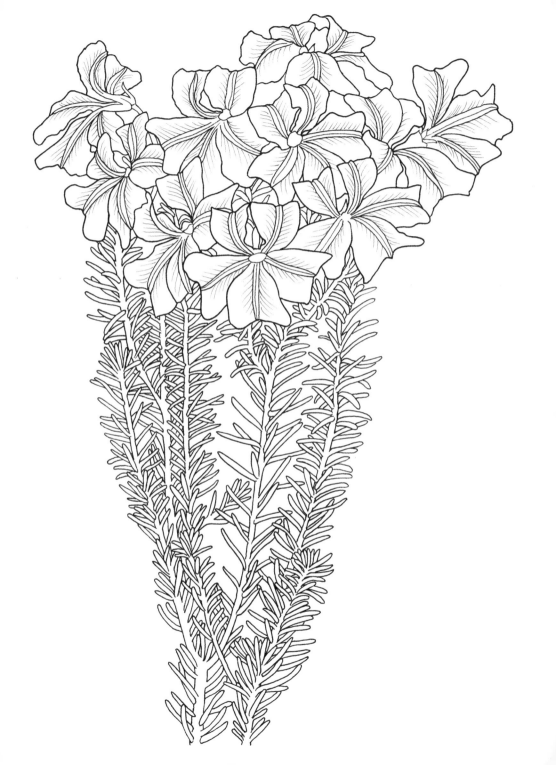

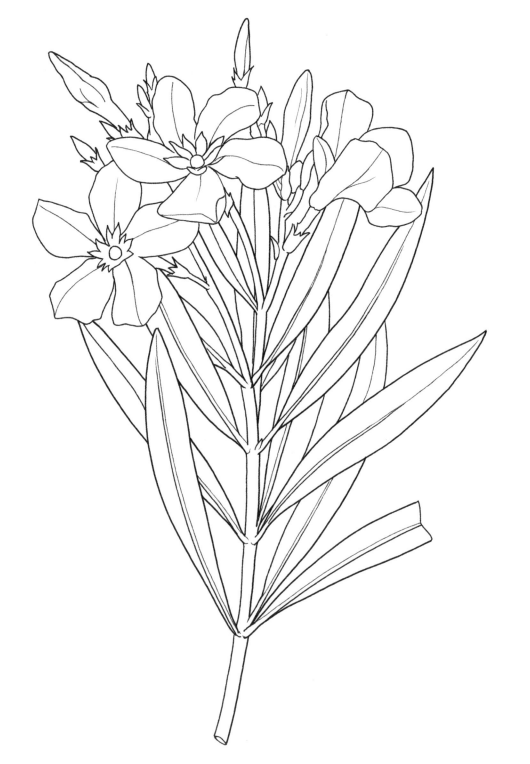

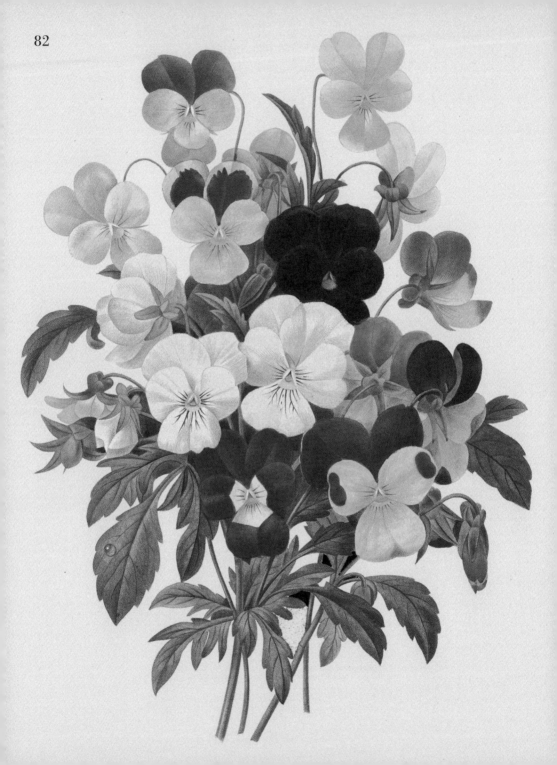

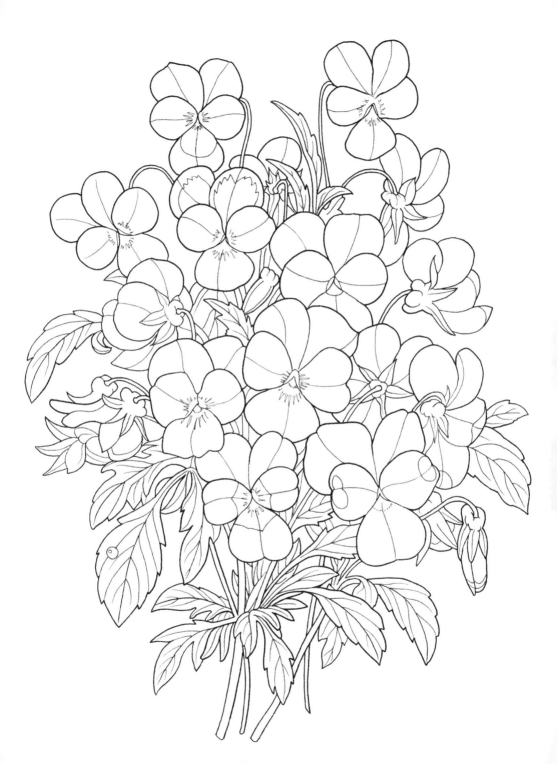

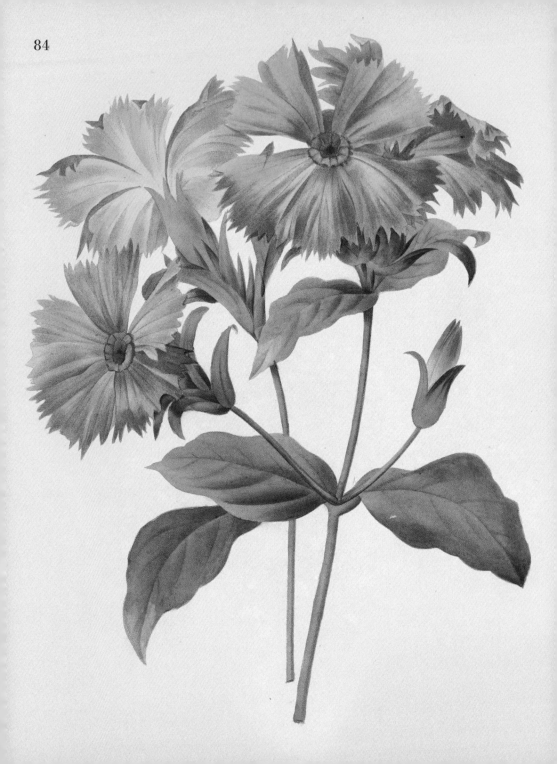

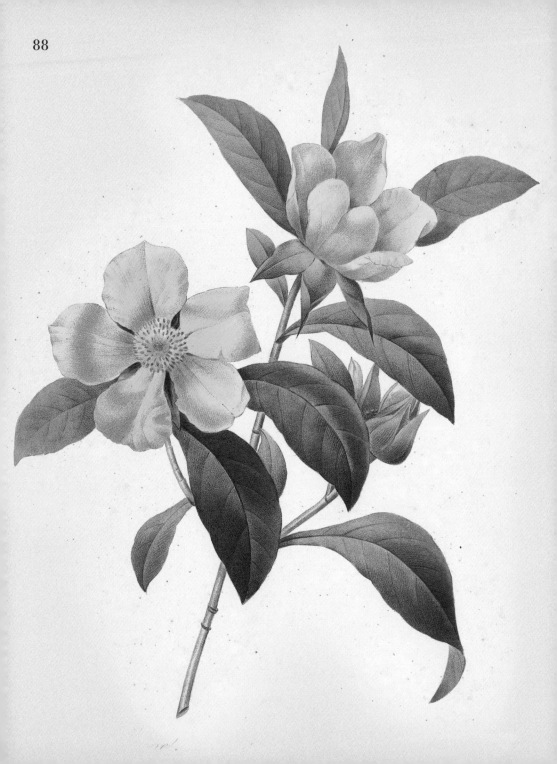

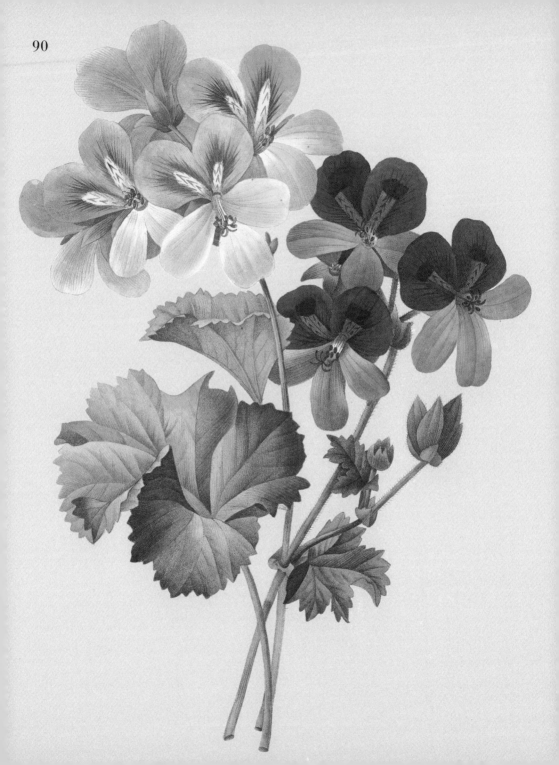

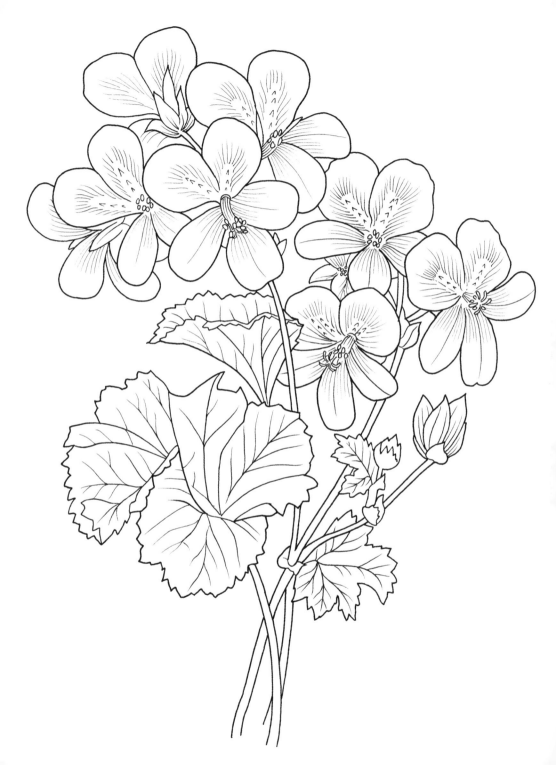

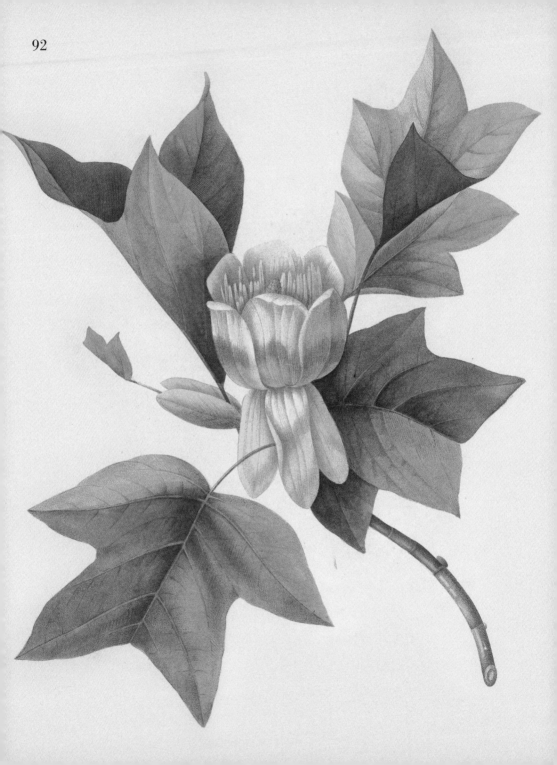

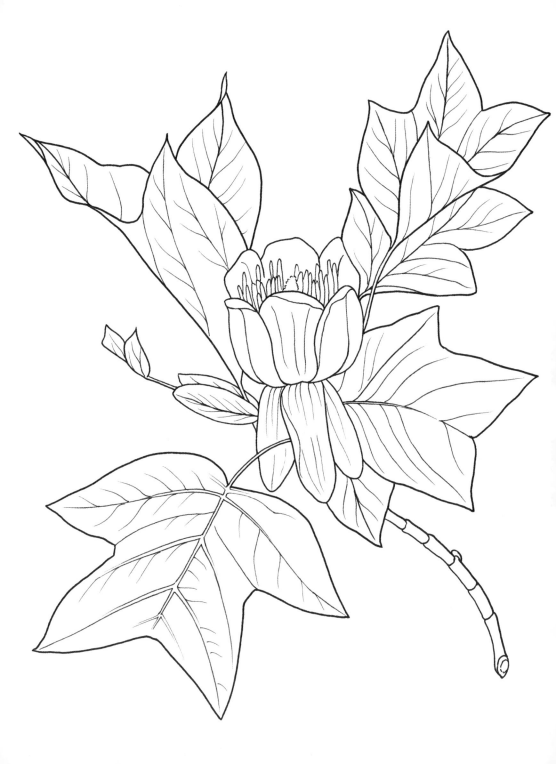

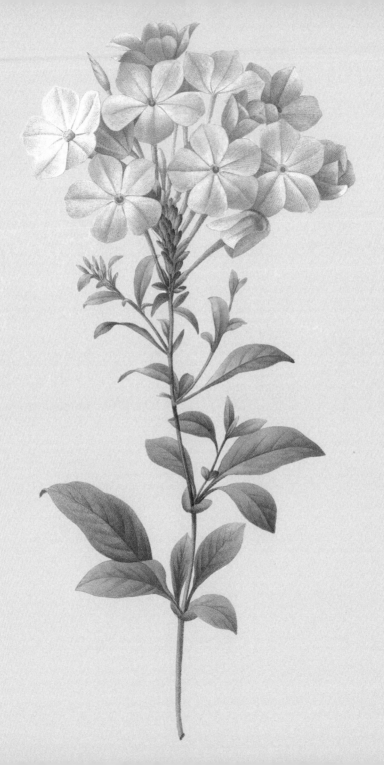

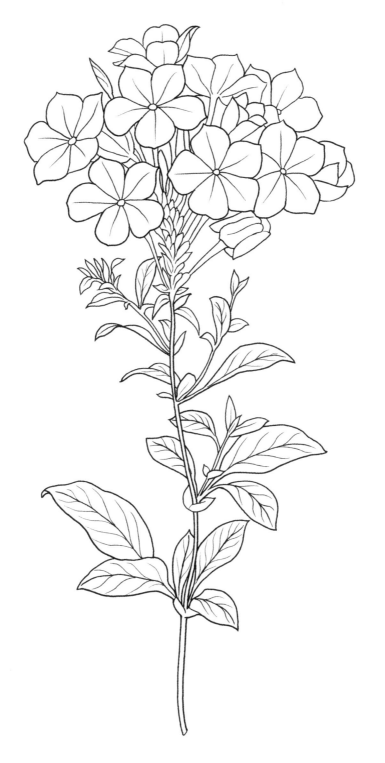

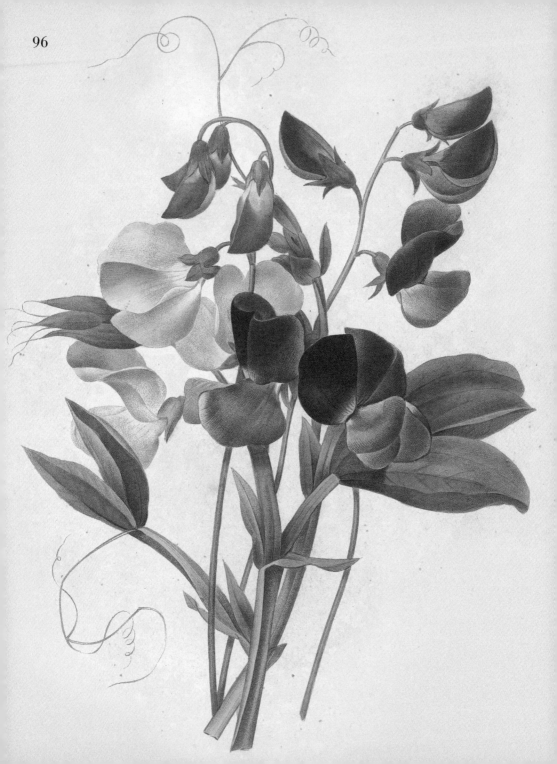

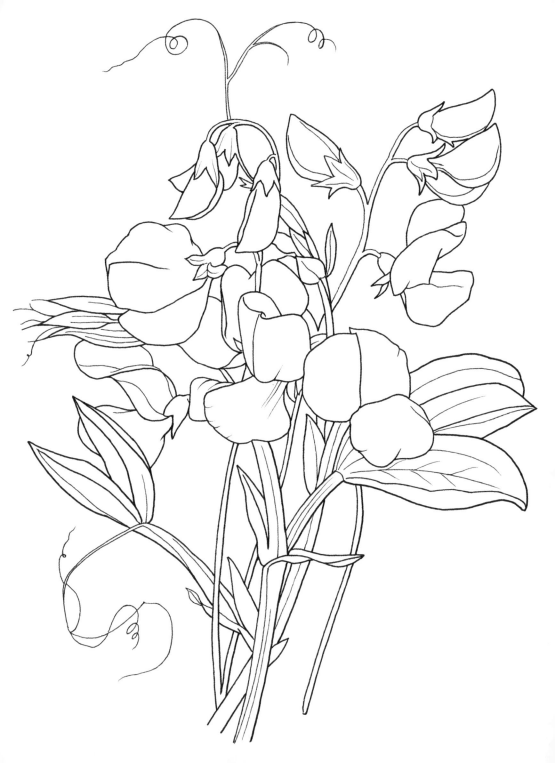

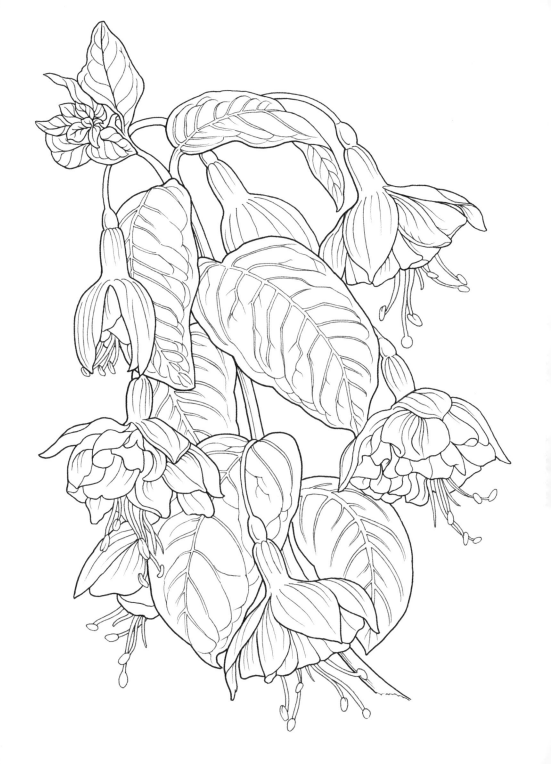

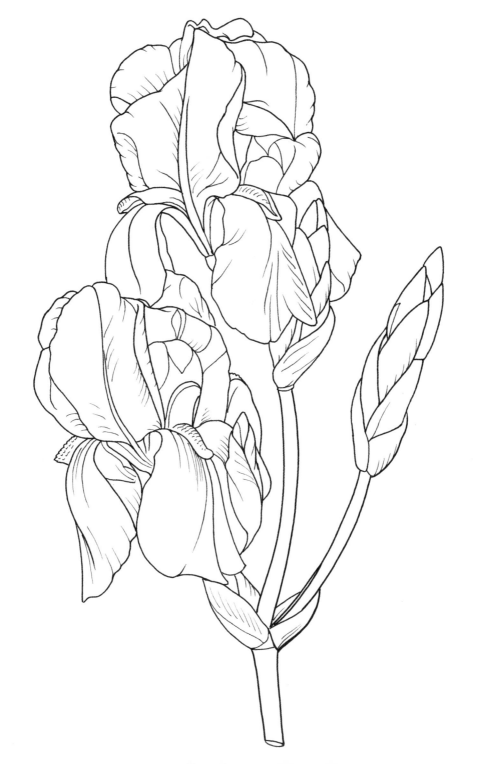

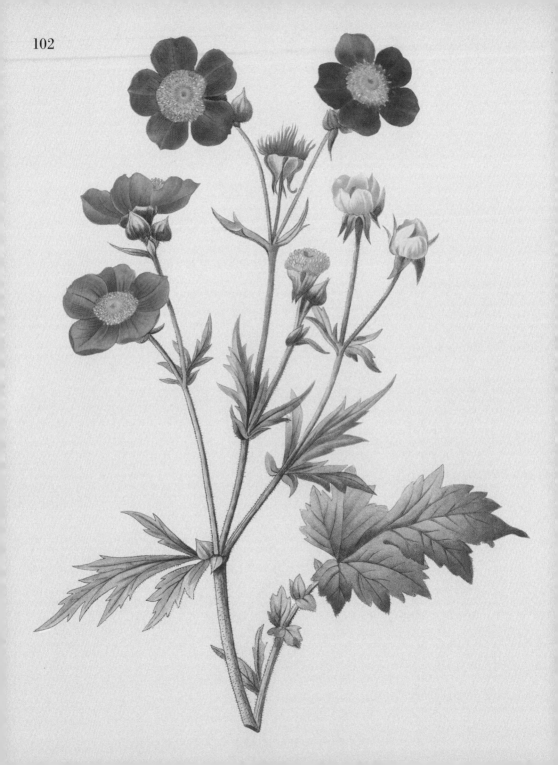

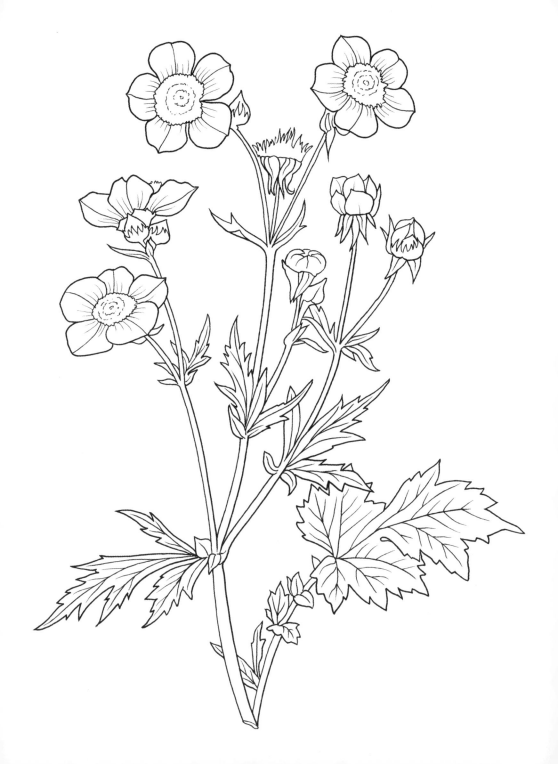

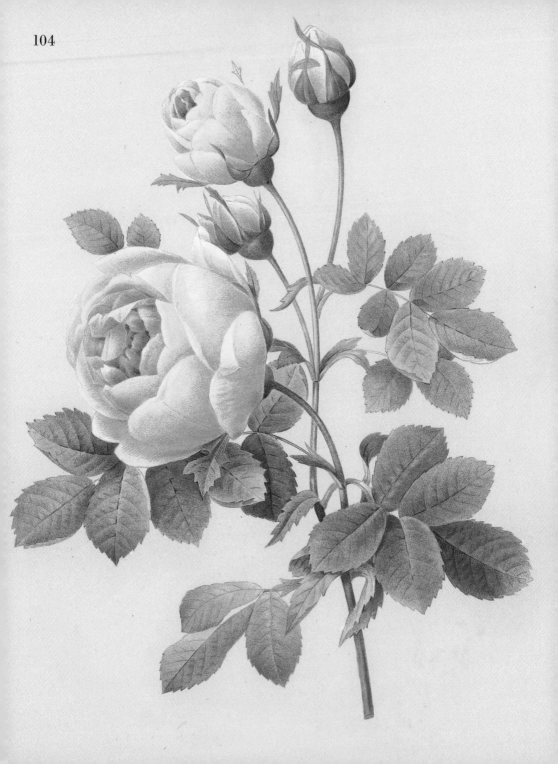

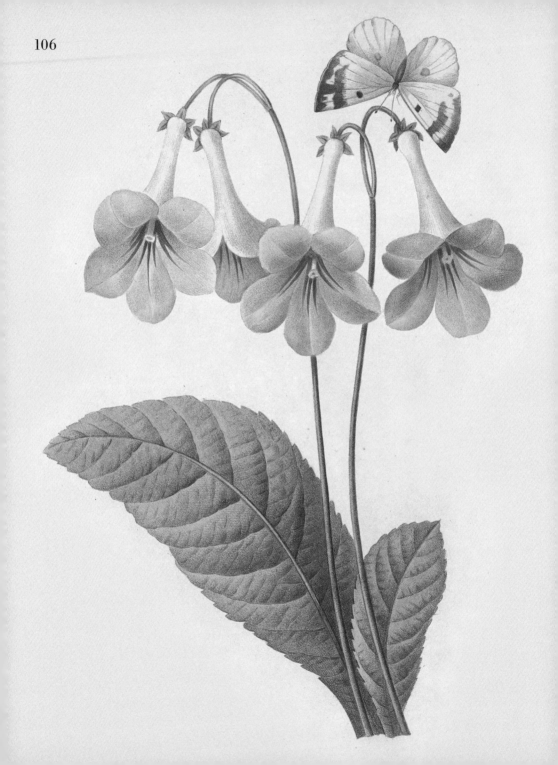

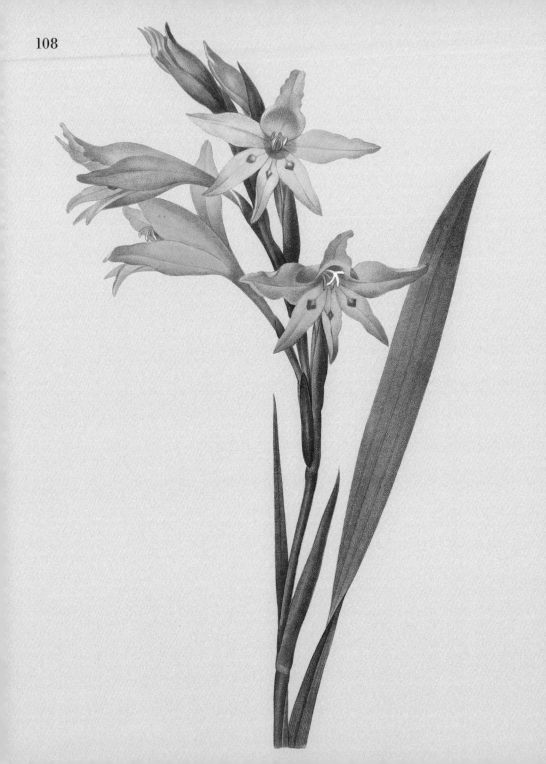

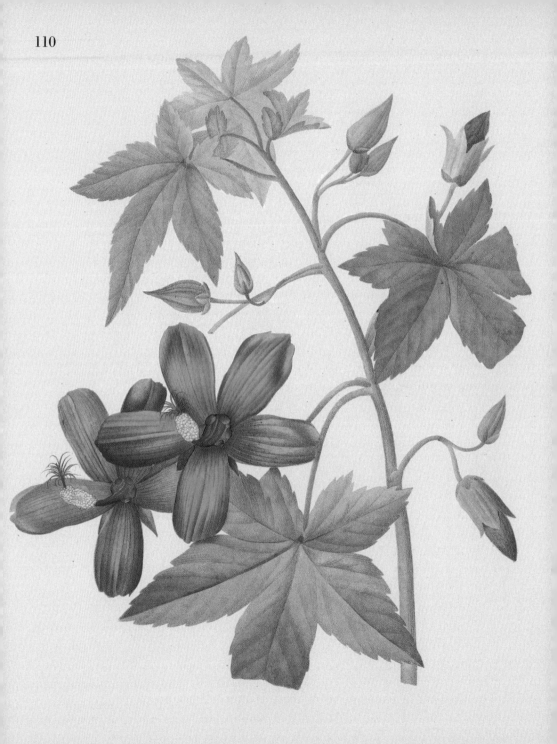

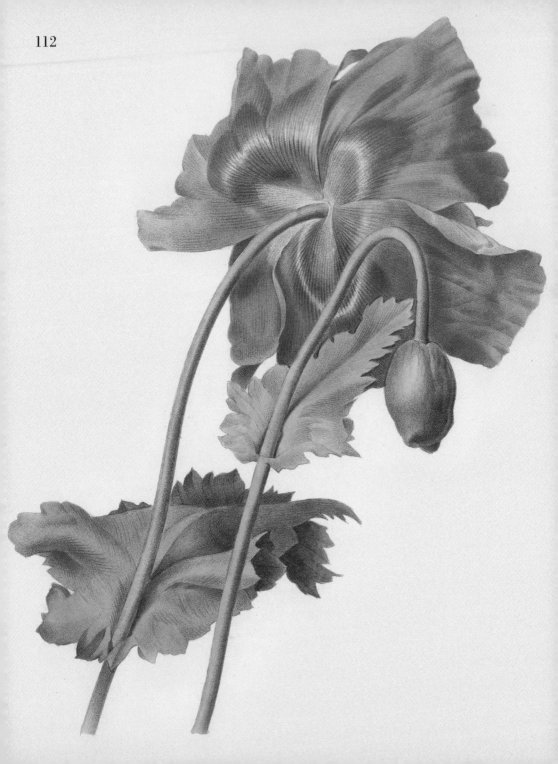

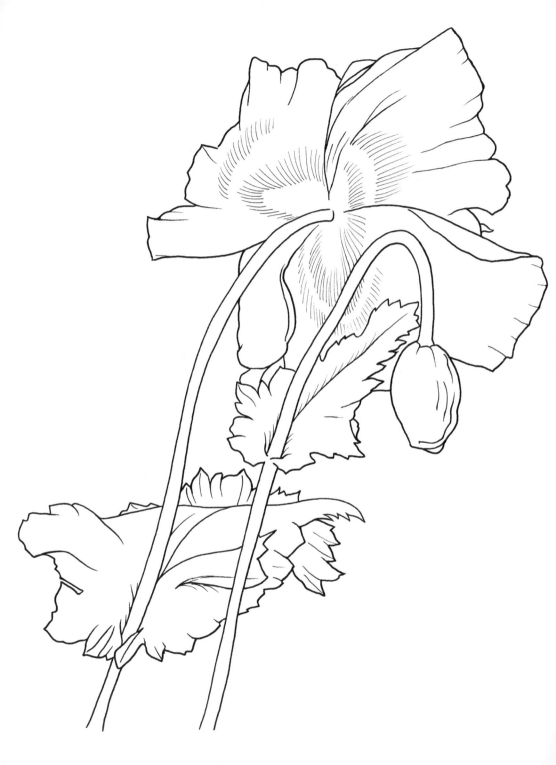

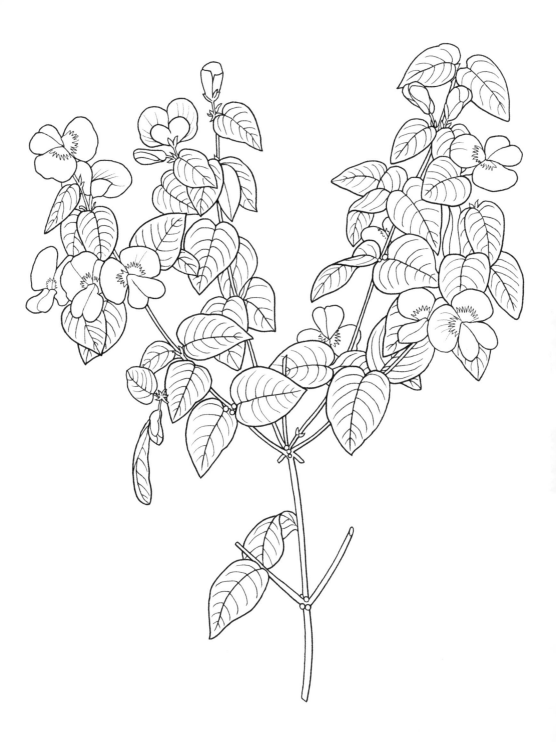

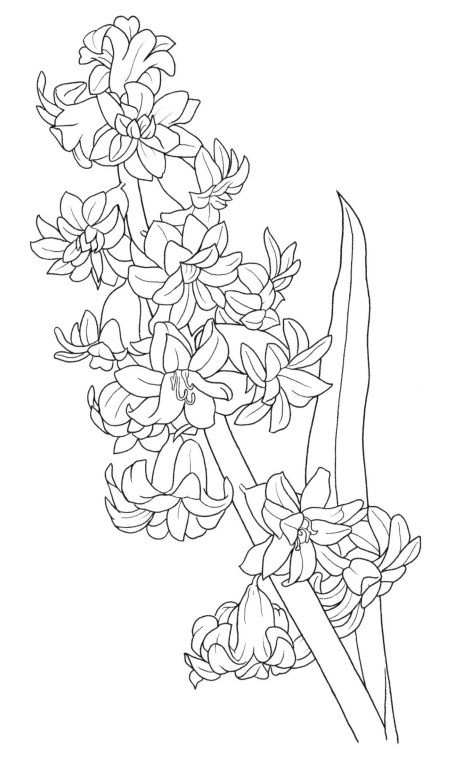

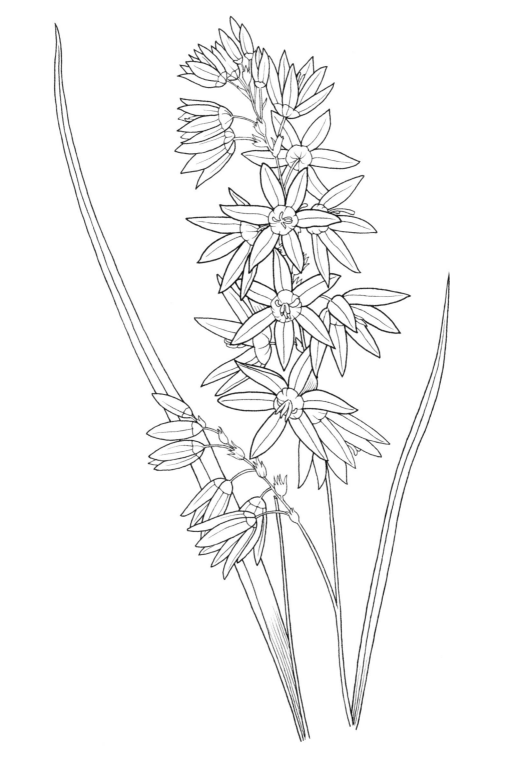

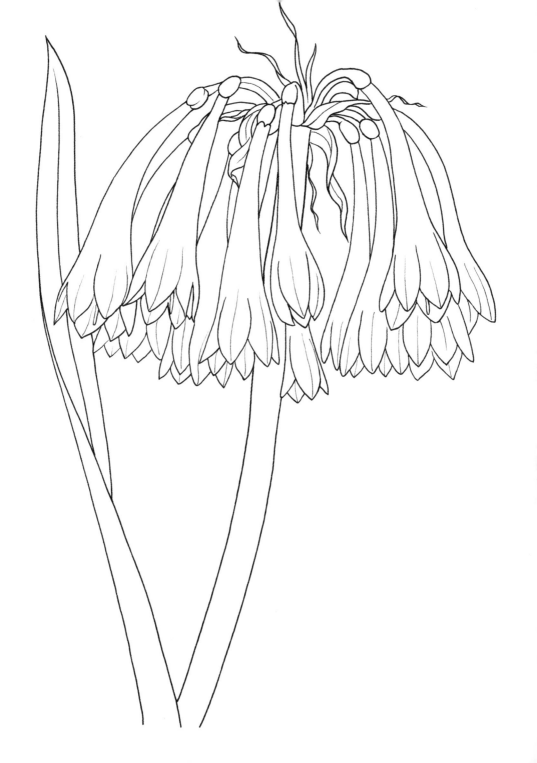

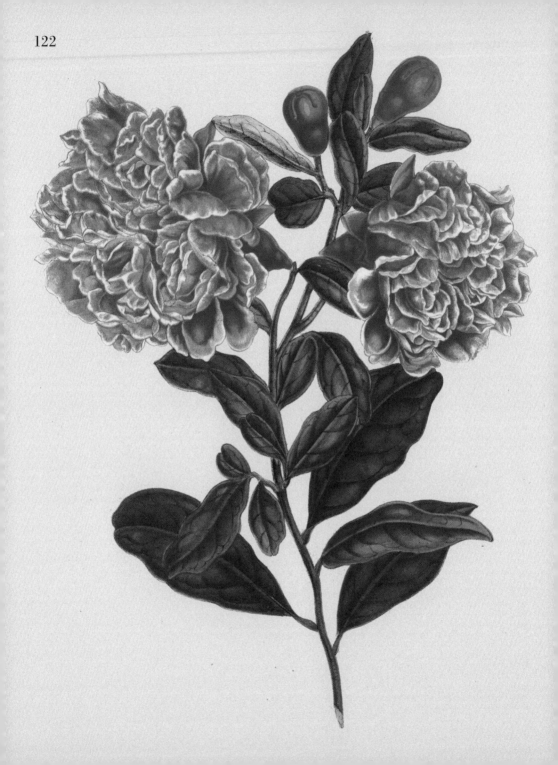

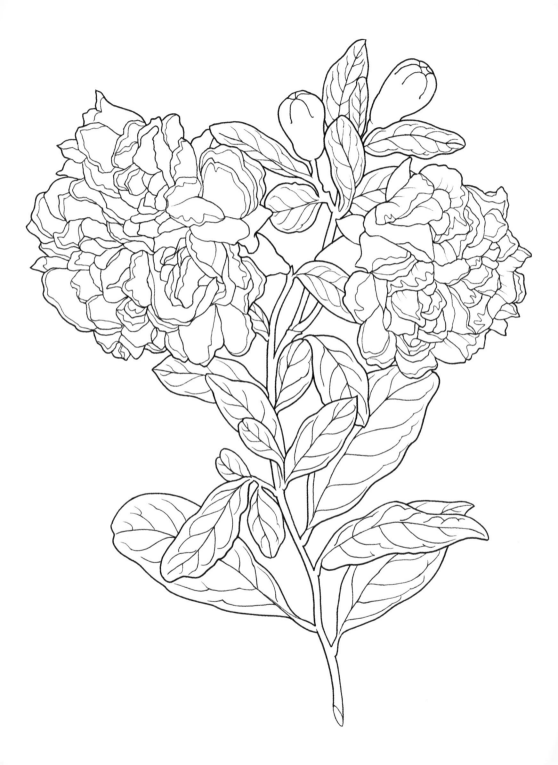

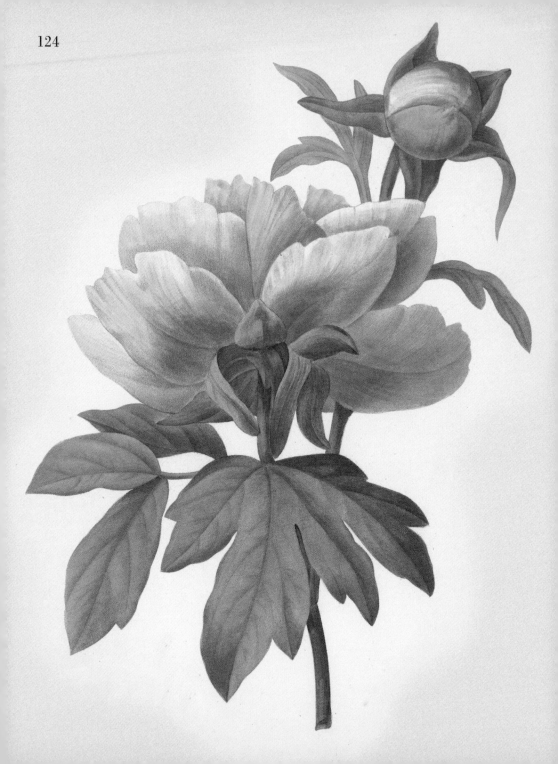

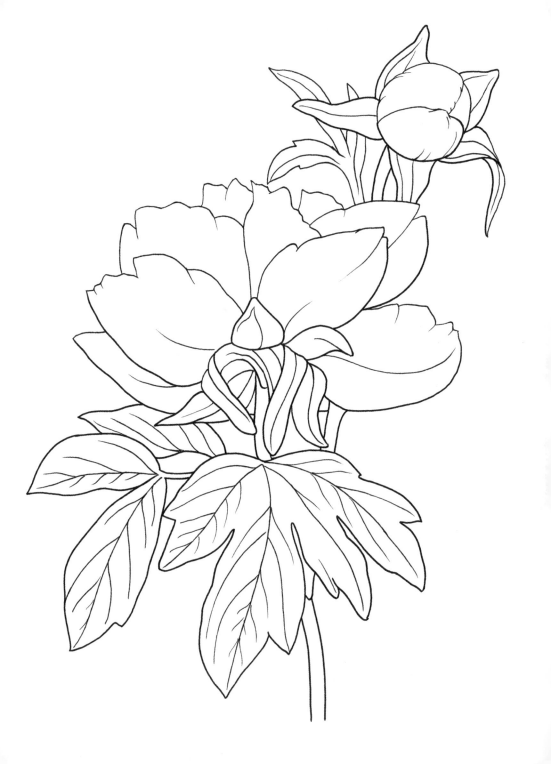

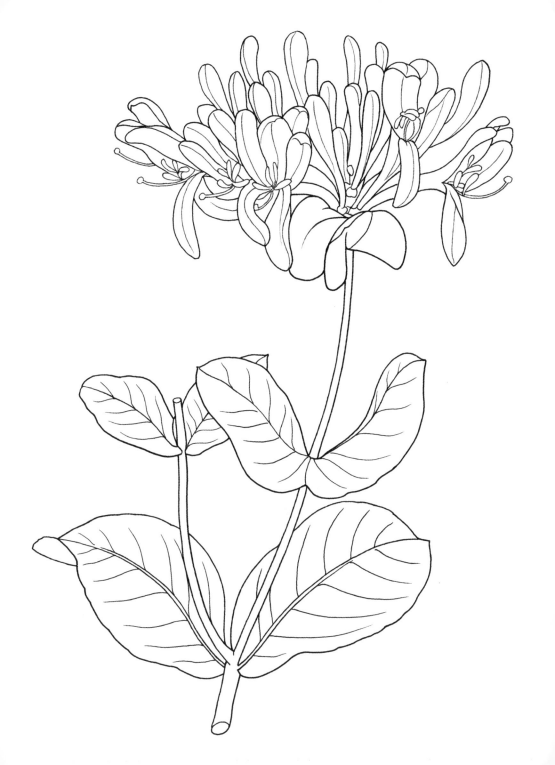

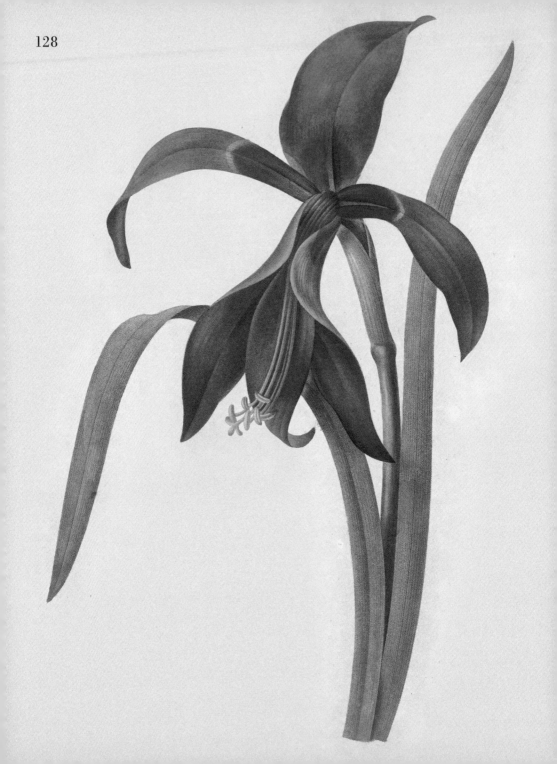

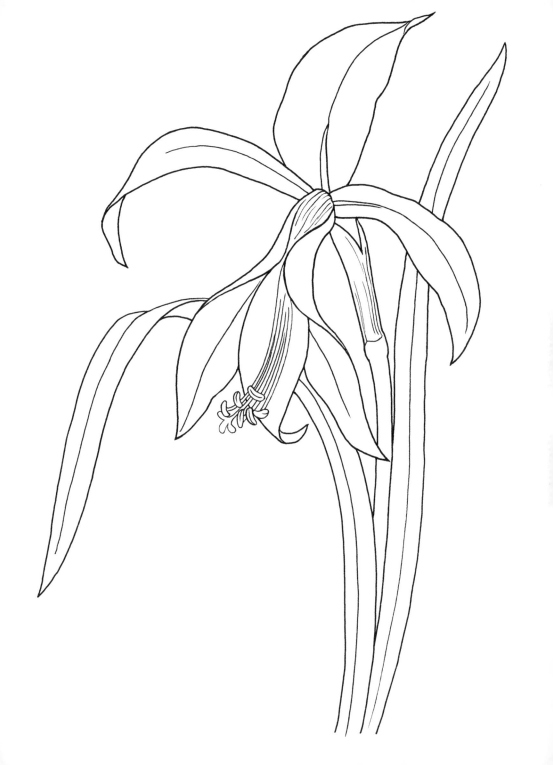

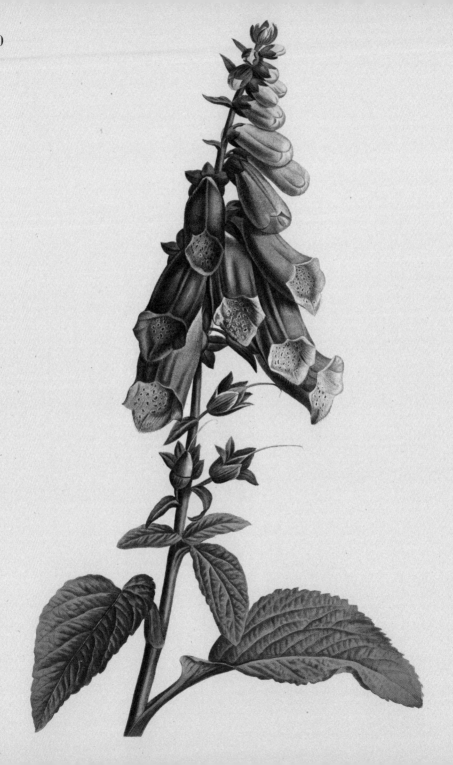

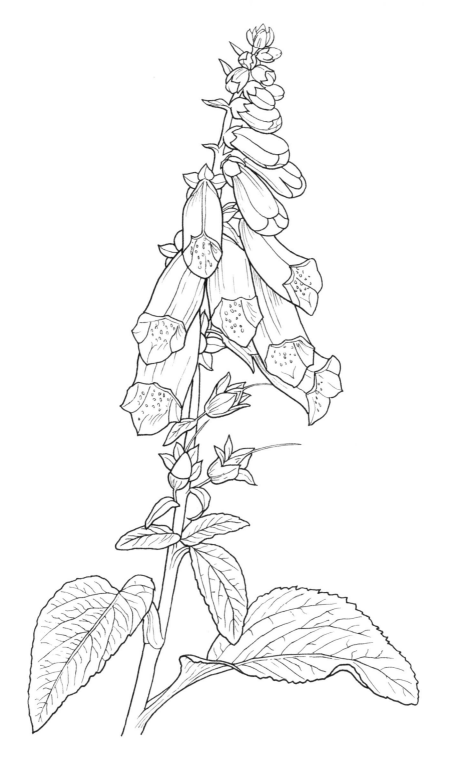

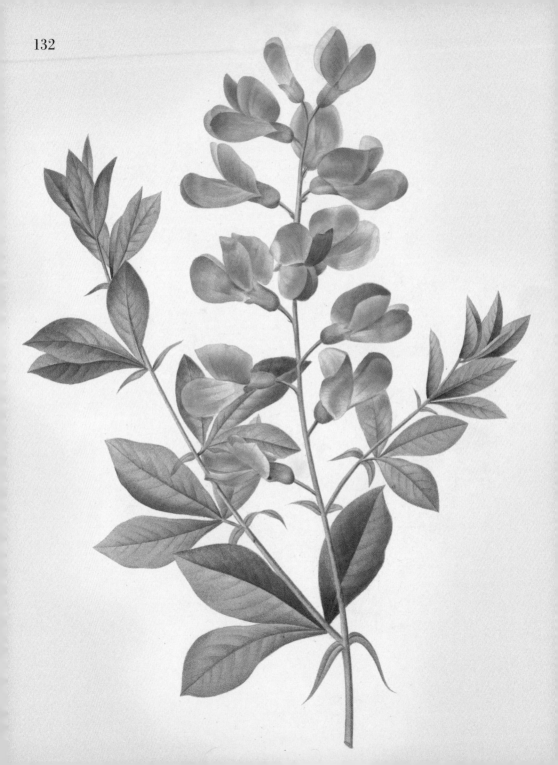

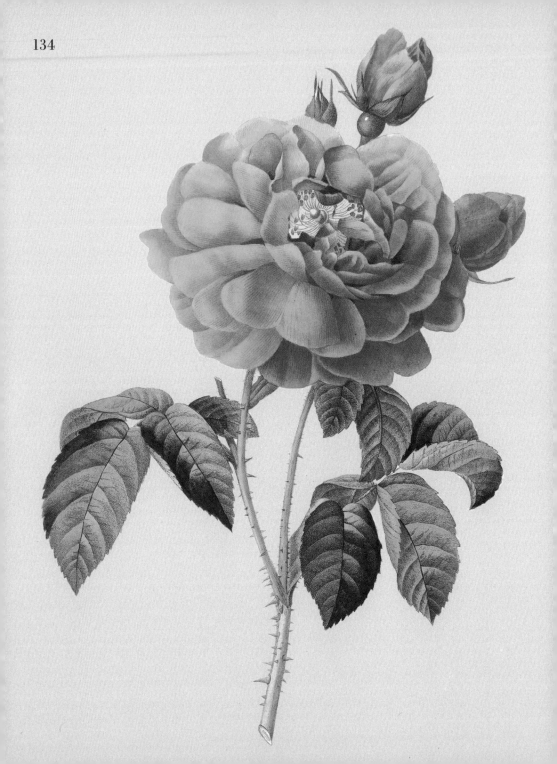

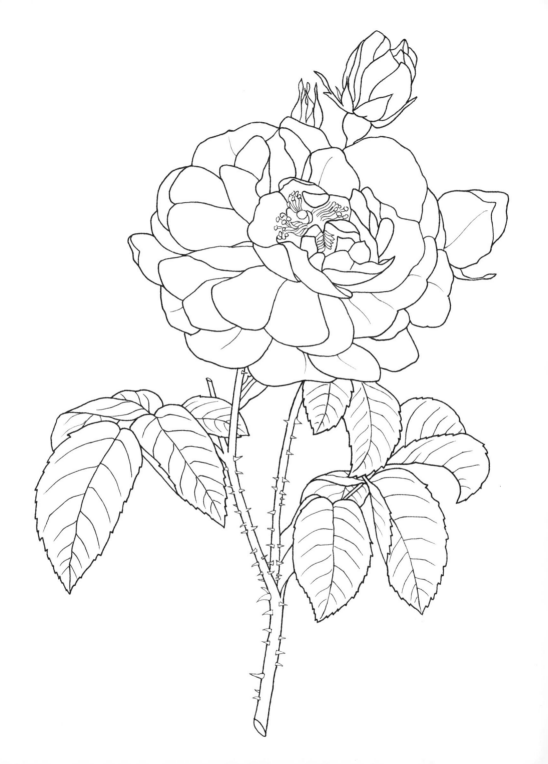

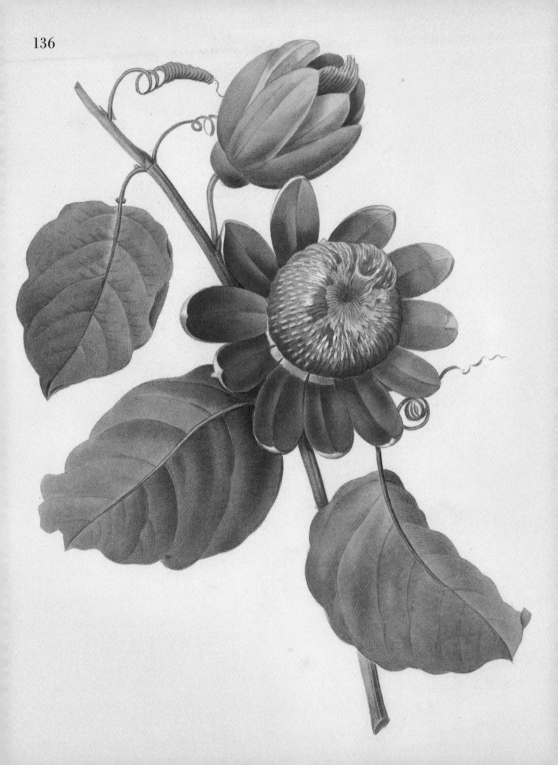

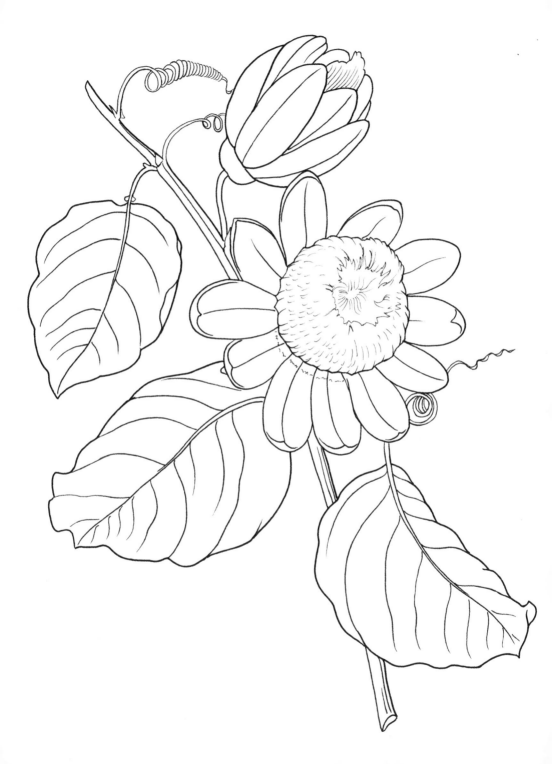

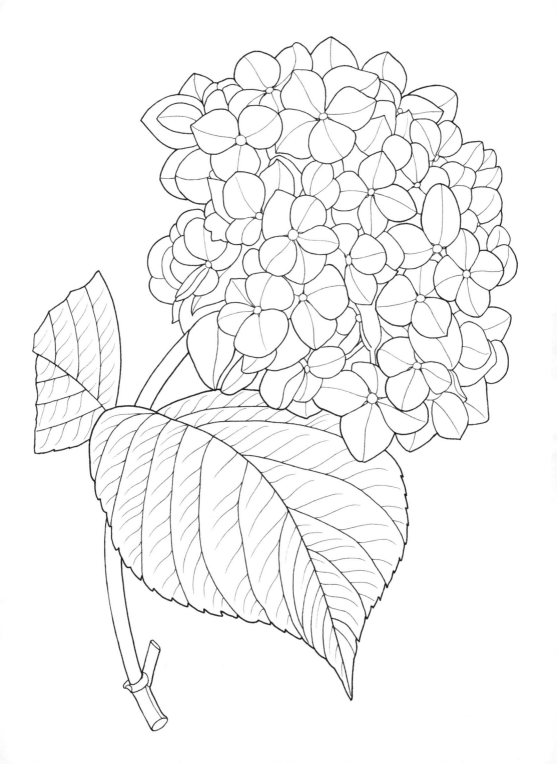

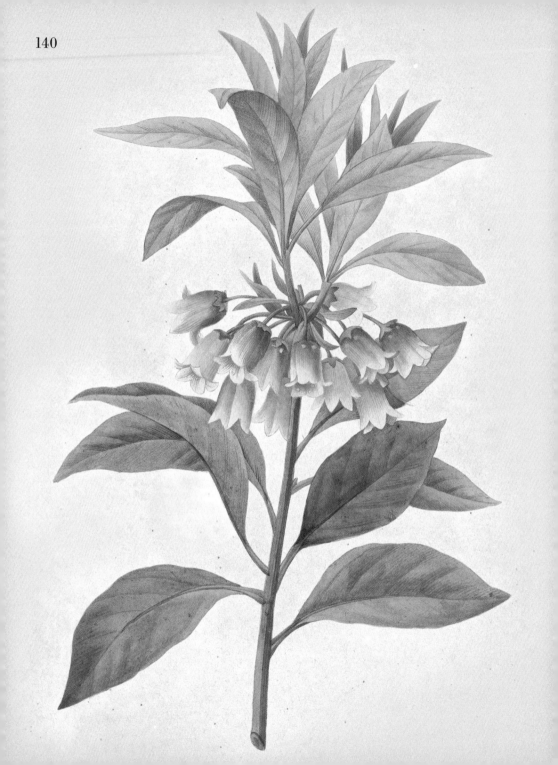

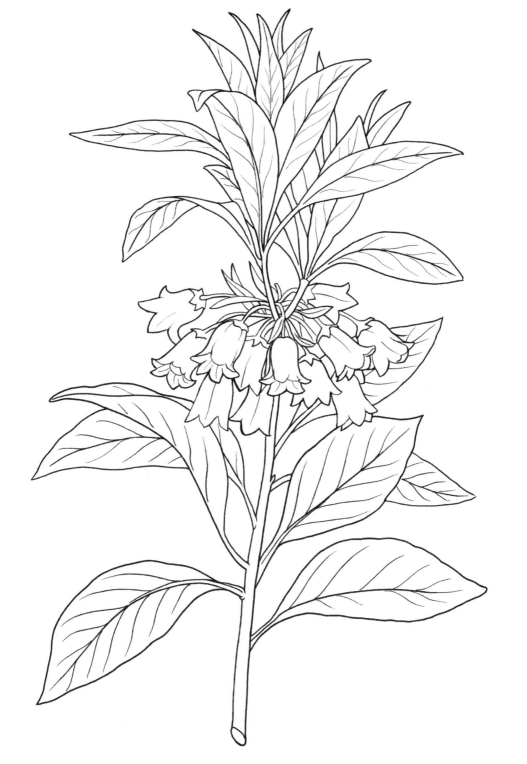

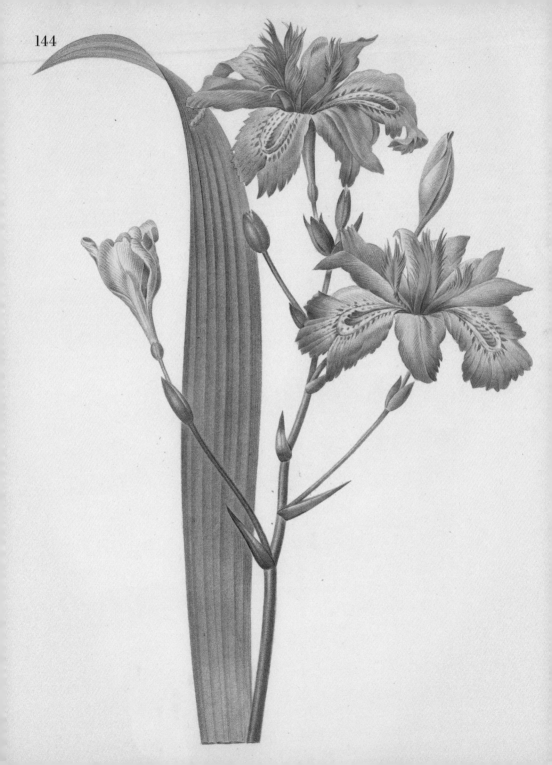

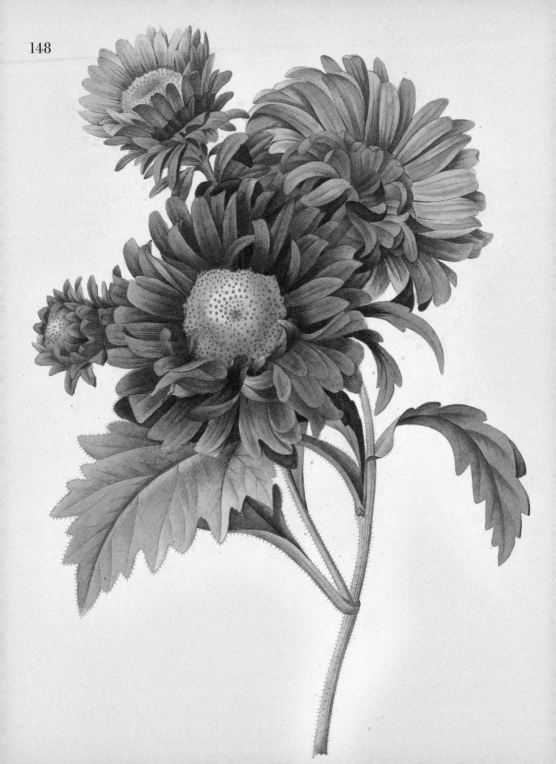

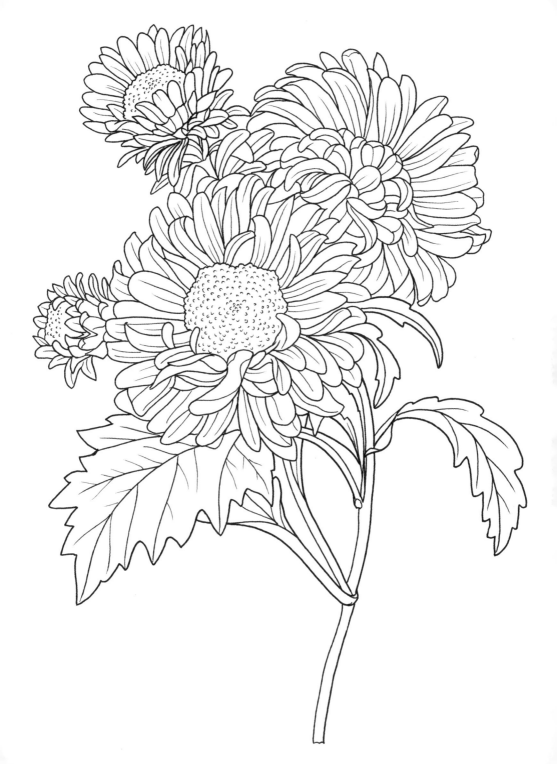

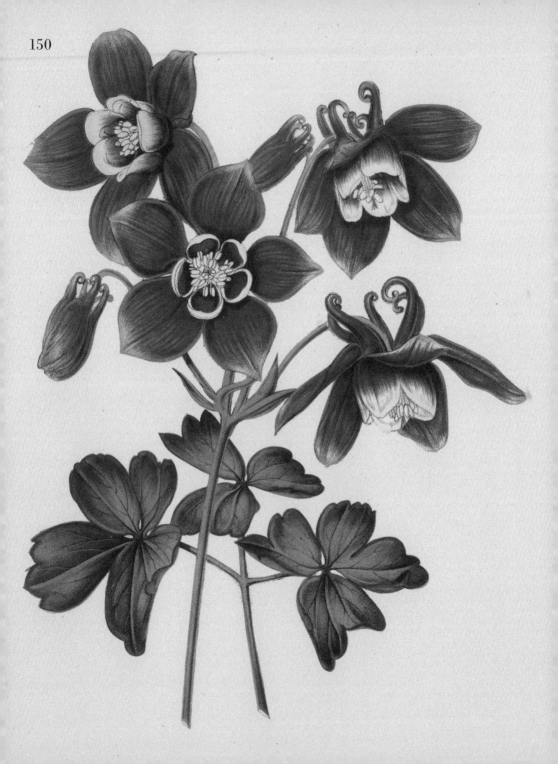

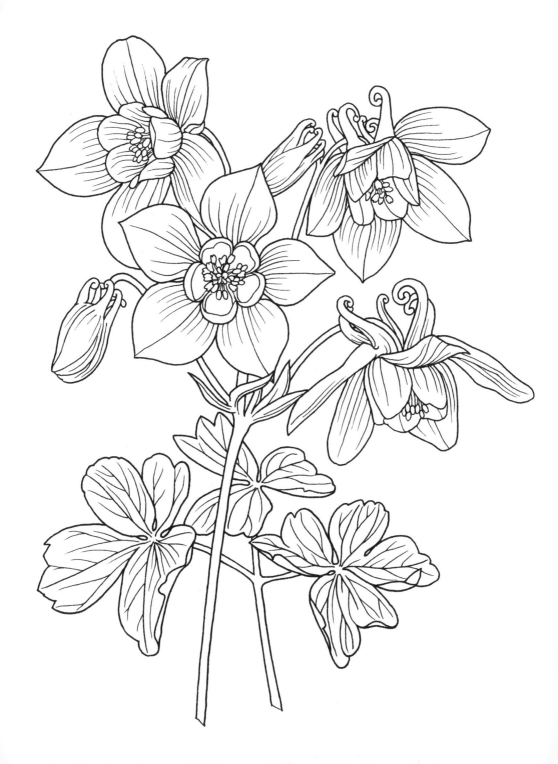

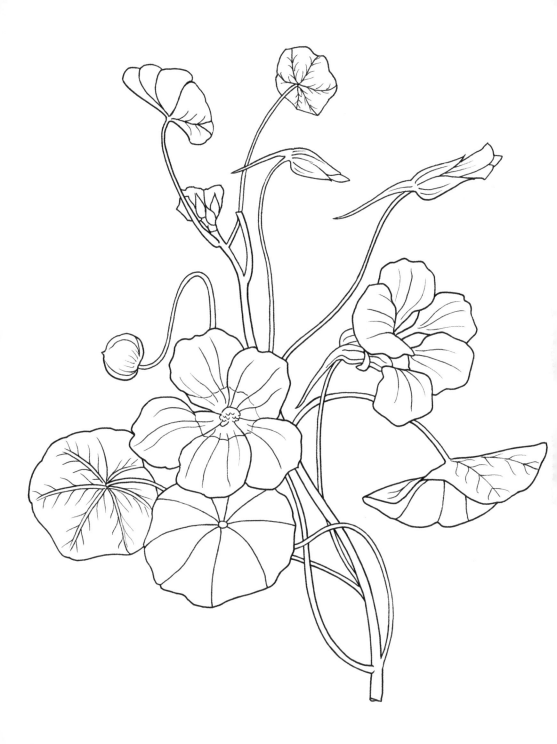

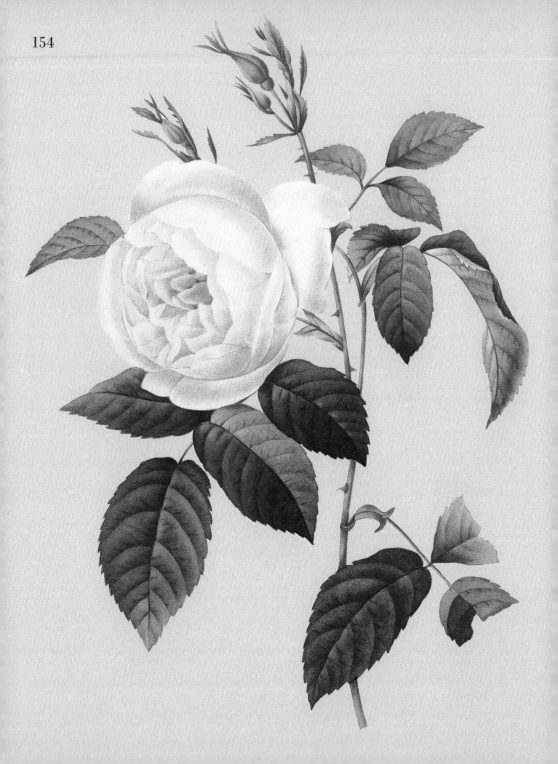

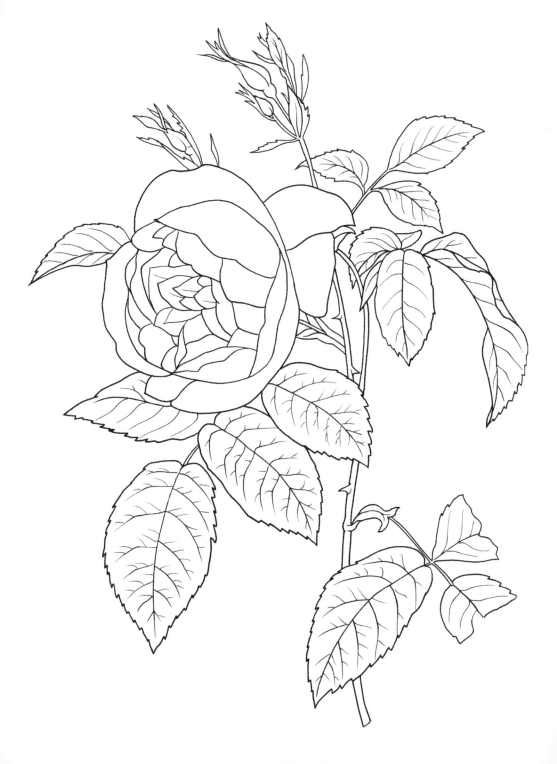

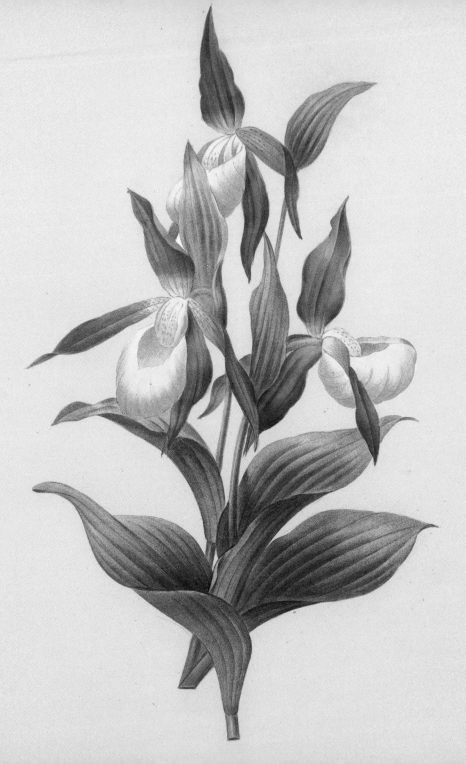

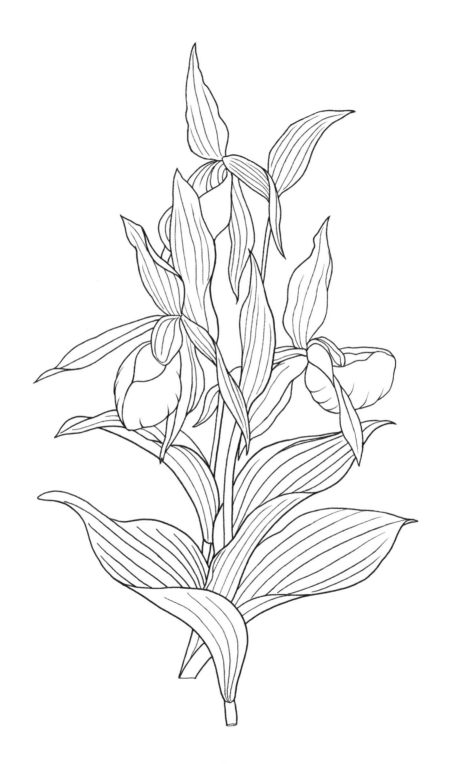

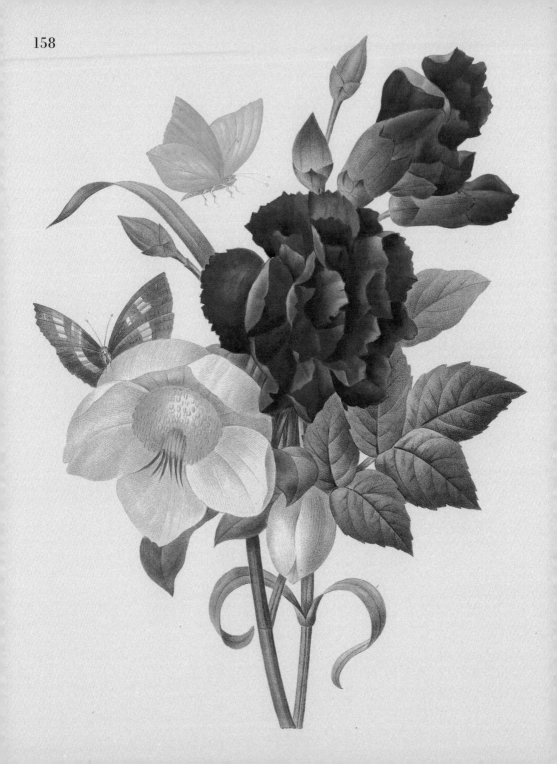

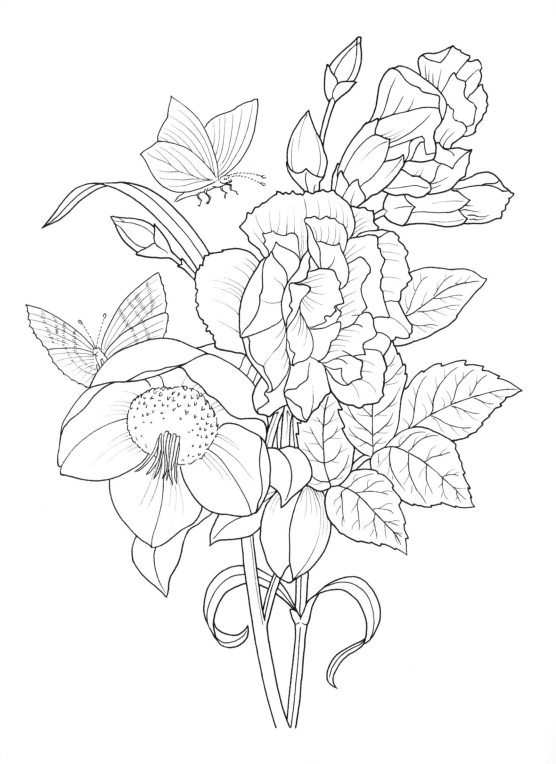

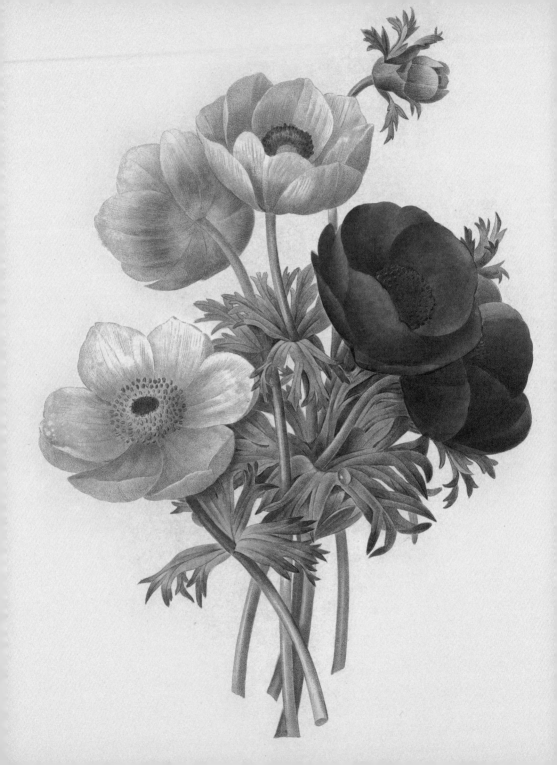